NATIONAL GEOGRAPHIC
PHOTOGRAPHY
FIELD GUIDE
PEOPLE &
PORTRAITS

SECRETS TO MAKING GREAT PICTURES

ROBERT CAPUTO

**NATIONAL
GEOGRAPHIC**

WASHINGTON, D.C.

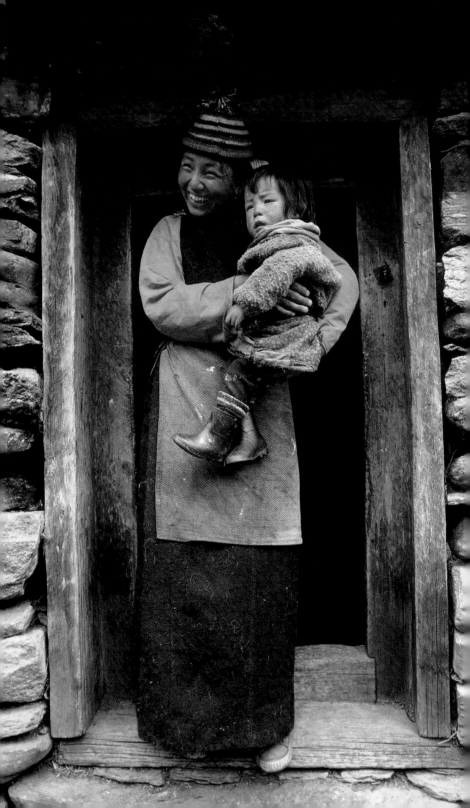

NATIONAL GEOGRAPHIC
PHOTOGRAPHY
FIELD GUIDE
PEOPLE & PORTRAITS

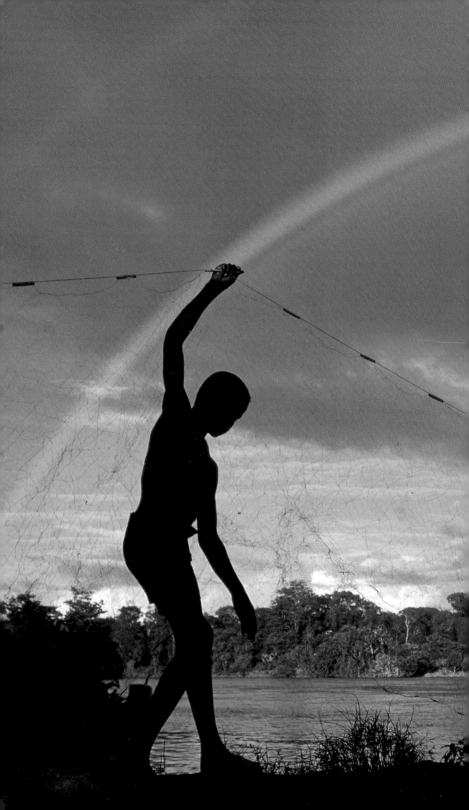

CONTENTS

PAGES 2-3: As a boy untangles his net on a river in Suriname, a ray of sunlight falls on his hand. For a split second, he appeared to hold a rainbow, and the photographer was ready to capture it on film.
Robert Caputo

OPPOSITE: Being friendly pays off. When a subject is happy and engaged, as this woman obviously is, the feeling comes through in the photograph. Paul Chesley

MENTION A FAMOUS OR INFAMOUS NAME—from Abraham Lincoln to Martin Luther King, Jr., Adolf Hitler to Saddam Hussein—and our minds immediately conjure up an image. Most of us have never met these people, never, in fact, come anywhere close to them. Yet we feel as if we know them because we have seen photographs that capture both their look and their character.

Other pictures of people work a different way: the Okie pushing through the dust storm, the Marines raising the flag at Iwo Jima, the woman crying out at Kent State. These are photographs not about individuals, but about moments in history. They provide information and evoke feelings about the impact of events on human lives. Still others, like many of the photographs in NATIONAL GEOGRAPHIC magazine, connect us with people from other lands and cultures that we will never have the chance to visit firsthand.

And there are personal pictures—of friends and loved ones, of ourselves when we were younger. These photographs are our memories, physical evidence of our link with time, and are among our most treasured possessions.

People are our most common photographic subjects, and probably the trickiest. It's easy to get photographs *of* people, less so to make ones *about* them. Effective people pictures, whether of relatives or strangers, convey both appearance and personality. They give us an impression of who that person is.

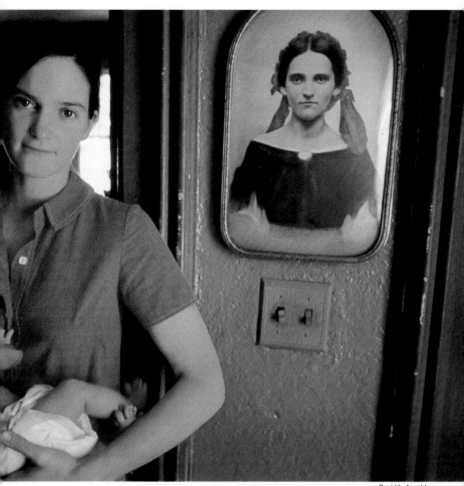

David L. Arnold

The most important part of making people pictures—or any other kind—is thinking. What do you want your image to say?

In this book, we'll explore ways to think about people pictures and cover techniques for making effective ones. We'll get insights and tips from National Geographic photographers. And I'll encourage you to practice, practice, practice. There's no substitute for making lots of pictures, and few other things are as much fun.

Always take advantage of shooting locations. When the photographer saw the striking resemblance between this woman and the portrait of her grandmother, he knew immediately what his photograph would be.

PEOPLE PICTURES fall into two categories: por-
traits and candids. Either can be made with or
without your subject's awareness and coopera-
tion. However near or far your subject, however
intimate or distant the gaze your camera casts,
you always need to keep in mind the elements
of composition and the techniques that will best
help you communicate what you are trying to
say. This is true whether you are working in a
studio or out in the street, whether you are mak-
ing a photograph of someone you love or some-
one who just happens to be passing by.

Again—and I cannot say this often enough—
you must first think about what you want your
photograph to show and say. With people pic-
tures, you know what the center of interest is—
the person who inspired you to make the image.
But what do you want to say about them? Once
you have determined that, you can use the com-
positional techniques we'll discuss in this section
to help you achieve your goal. Remember that
these are guidelines only, not hard and fast rules.
Break them if that's what makes the best image.

For example, if you are photographing some-
one walking or running across the frame, or
even looking across it, the convention is to leave
more room in front of them than behind them
so they have space to move into with the motion
implied in the image. But you can also make
dramatic images that are composed in exactly
the opposite way, with the person moving out

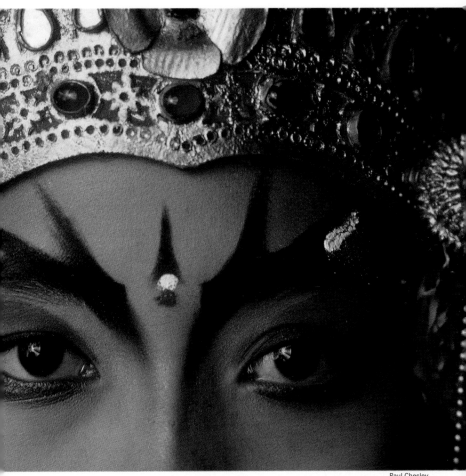

Paul Chesley

of the frame. Look carefully, think about what you want to say, consider whether to follow or break the rules of composition, and make images that are your own.

The best way to learn about composition is to study the work of painters and other photographers. Visit museums. Browse through art and photo books. When you come to an image that strikes you, study it. Why do you like it? How did the artist achieve that impact? Where was the camera? What length lens was used? How much

Get close and be bold. The impact of this photograph comes from the dramatic lines and colors and the intimacy of the woman's gaze. Notice how the face has been framed slightly off-center to heighten the impact.

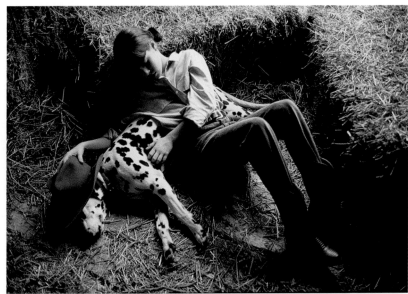

Annie Griffiths Belt

Always watch for intimate moments, and search for the composition that captures the mood. Dramatic lighting from a hayloft window and the angle formed by bales that nestle the girl and dog give this image a serene feeling. The hat adds a touch of humor.

depth of field is there? What is the light like and where is it coming from? Where is the subject placed? Has the photographer used foreground elements, leading lines, patterns, shapes, and textures? By studying good images you will learn how to compose your own.

Get Closer

The most common mistake made by photographers is that they are not physically close enough to their subjects. In some cases this means that the center of interest—the subject—is just a speck, too small to have any impact. Even when it is big enough to be decipherable, it usually carries little meaning. Viewers can sense when a subject is small because it was supposed to be and when it's small because the photographer was too shy to get close. When you look at the work of other photographers, pay attention to how they fill the frame. Everything in it should

serve the message of the image. If you see things in your viewfinder that distract from what you are trying to say, get rid of them. With people photography, this usually means getting closer.

Don't be shy. If you approach people in the right way, they'll usually be happy to have their picture made. It's up to you to break the ice and get them to cooperate. Joke around with them. Tell them why you want to make the picture. Practice with people you know so that you are comfortable; people can sense when you aren't.

Work your way into a situation. If you see something interesting, don't be satisfied with just a wide shot. Think about the essence of what you are photographing and work closer and closer until you have isolated and captured it. Don't be shy. People are usually happy to show you what they do well.

Robert Caputo (all)

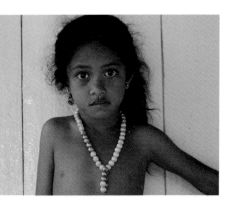 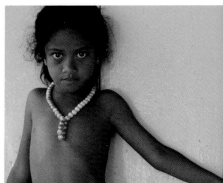

Robert Caputo (both)

In the image above left, the girl is centered like a bull's-eye in the frame. Using the rule of thirds (above, right) makes for a better image. The girl's arm becomes a graphic element across the colorful wall. The image on the opposite page breaks the rules by placing the subject dead center. Because the photographer got down low and placed the subject against the sky, the image works.

Avoid the Bull's-Eye

The second most common mistake is the bull's-eye—placing your subject smack dab in the middle of the frame. We've all seen (and most of us have made) images like this—head in the middle, lots of room above and on the sides, feet cut off. Bull's-eye photographs are usually boring. We find them static and with little to interest us but the subject, which we look at only briefly before we get ready to turn the page. Move the camera around, placing the subject in different positions in the viewfinder. After some practice, you will sense when it is right.

The Rule of Thirds

Imagine that your camera's viewfinder is etched with lines that divide it into equal vertical and horizontal thirds. The rule of thirds is a compositional technique that places your subject at one

William Albert Allard, National Geographic Photographer

of the "sweet spots" where these lines intersect. It has been used in painting and photography for a long time for the simple reason that it works; our eyes find such placements of subjects to be both pleasing and dynamic. Next time you go to a museum or browse through art or photography books, look out for the rule of thirds. You will notice that it crops up again and again.

Let's say you are making a picture of a friend sitting in a café. If you place her dead center in the frame, the viewer's eyes will immediately go to her—they will pay little attention to the area around your friend because the viewer understands that the photographer was less interested in it than in the subject. If, however, you place your friend one-third of the way into the frame, viewers will get a much different feeling. They will take in more of the ambiance of the café, and intuit that the image is one of a person in a café rather than just of a person.

At which intersection you place your subject

The rule of thirds, the use of leading lines, and the decisive moment come together

David Alan Harvey

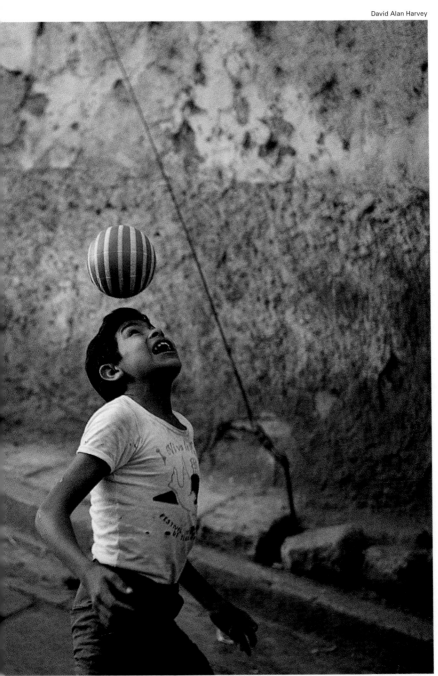

to capture a child's playful joy and a sense of the environment in which he lives.

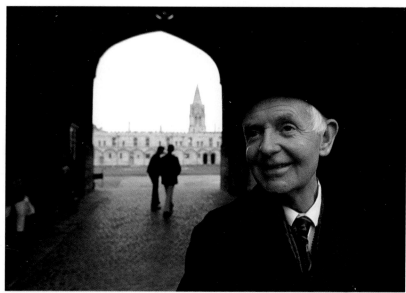

Annie Griffiths Belt

This gentleman's face, close to us and softly lit, stands out nicely against a view of Oxford University. By using the rule of thirds to create an interesting and balanced composition, the photographer has made a portrait of both a person and a place.

is determined by what else is in the scene. Look carefully. If your friend is on the right, do the things in the frame to the left help or harm your image? If it doesn't look good, move the camera so she is on the left. Do you want her at an upper or lower intersection? If there's a nice awning above her, put her at a low intersection so you can include it. Remember, everything in the viewfinder will be in the photograph, and everything should have a reason for being there.

Foreground Elements

You can use foreground elements to lead your viewers' eyes into the frame and to your subject. They can be almost anything from a leading line to objects that either literally or graphically reinforce the message of the image. In a studio or a room, you might want to have a stack of books or a pad of paper and pen in the foreground of a portrait of an author. In the street, pyramids of

Robert Caputo (both)

Without something to draw interest in the foreground, the image at left has little impact. By waiting for the woman to make her way through the wheat field, the photographer made a much more dramatic picture and at the same time provided more information about both the place and the people who live there.

fruit point to a smiling vendor. Waving arms in a crowd point to a candidate giving a speech. A winding path leads to a couple holding hands. Always look for ways to use things in the foreground to point the viewer to your subject.

Be careful of placement. Foreground elements should reinforce your image, not take it over. Don't let them obscure or compete with what the photograph is really about.

Depth of Field

Depth of field is one of the most important elements of photography because it allows you to control how a viewer perceives a scene. When we look at objects at different distances from us in the real world, our eyes automatically focus on whatever we look at, no matter how near or far. We can bring anything we want into sharp focus. The photographer controls what's sharp and what isn't.

Tip

If you use objects other than your main subject in the foreground, be careful of placement. You don't want to obscure or detract from your subject.

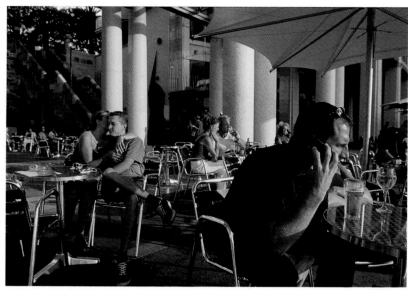

Annie Griffiths Belt

The atmosphere of this café comes through because of the dramatic composition achieved with the use of the rule of thirds and foreground elements—and great depth of field. With everything in sharp focus, we immediately get a feeling about what kind of café this is.

You can use depth of field to focus your viewers' attention on your subject and to reinforce the message you want to convey. Do you want your subject to stand out from the background or to blend in with it? If you are using foreground elements, as we discussed above, do you want them to be in sharp or soft focus?

Depth of field is determined by three things: focal length, distance between camera and subject, and aperture. The shorter the lens, the greater the depth of field. The smaller the aperture, the greater the depth of field. A very wide-angle lens will have great depth of field at almost any f-stop. A long telephoto will have very little at even the smallest one. Some SLR cameras have depth of field preview buttons, so you can check it before making the image. If your camera doesn't have a depth-of-field preview button, you can use the depth-of-field scale on your lens to estimate what would be in focus, or you could invest in a Polaroid back.

Chris Johns, National Geographic Photographer

By choosing this perspective and using great depth of field, the photographer draws us into the scene to see what the man sees. With little depth of field, this effect would have been lost.

In the café setting, look carefully for possible foreground elements and also at the background behind your friend. What you include and how you treat what you include will have dramatic effects on your image.

Let's say you're sitting across the table from your friend and there are coffee cups on the table. You might want to include these in the image and so will be using a wide-angle lens. Do you want the objects on the table to be in sharp or soft focus? If you want them to be soft, focus on your friend and use a large aperture. If you want them to be sharp, use an aperture small enough to have both the objects and your

Annie Griffiths Belt

Always look for an unusual way to tell the story. This image tells us a lot about a fashion shoot by looking at it in a different way. If the models were not sharp enough—if there had been little depth of field—the image would not have worked.

friend in focus. In both cases, check the depth of field with the preview button, if your camera has one. If you're using a small aperture, you'll need a slow shutter speed. Be aware of any camera or subject motion at speeds below 1/60 of a second—it might cause blurring. Use a tripod, electronic flash, or faster film if needed.

What about the background? Look at it carefully. If it's too distracting or if it looks as if your friend might melt into it, you might want to have very little depth of field so that the background becomes a soft-focus mélange of shapes and colors. Your friend in sharp focus will then stand out from it. In this case, you might find that your wide-angle can't throw the background far enough out of focus, and you may need to switch to a longer lens. If you want to see sharp detail in the background, make sure you have enough depth of field to do so.

A good exercise that will help you see the effects of different depths of field is to shoot the same scene at several different f-stops, from very large to very small. Compare the photographs, noting how the changing depth of field helps or harms the image.

Other Techniques

Whenever you are looking through the viewfinder of your camera, be on the alert for elements that will enhance both the look and the message of your photographs: patterns, shapes, colors, textures of surfaces, frames within your frame. Look for anything that makes the subject stand out, either by leading to it or by contrast.

In our café example, perhaps your friend is wearing a color that stands out from the rest of the crowd, or she is facing one way and everyone else the other. You may be able to shoot her

Tip

Every time you hold your camera to your eye, look for leading lines, foreground elements, frames—anything you can use to lend dynamism to your image. Photographs are two dimensional, but it helps if they look and feel three dimensional.

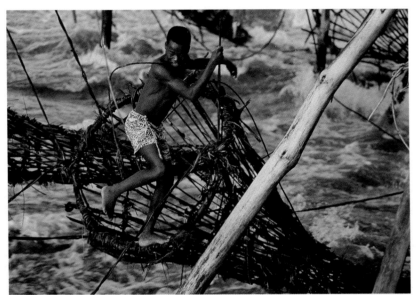

Robert Caputo

Graphic elements help make an image dynamic. The pole and the boy above are parallel and compressed together with a telephoto lens. The basket, thrusting at a right angle to the pole, seems to lift the boy up. In the image below, a metal fence screens and lends a bit of mystery to a familiar summer scene.

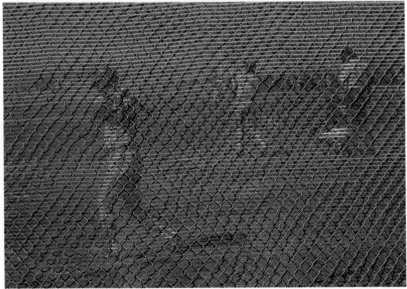

William Albert Allard, National Geographic Photographer

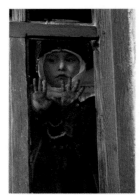

James L. Stanfield

Robert Caputo

Annie Griffiths Belt

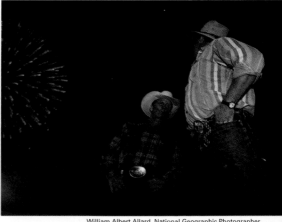

William Albert Allard, National Geographic Photographer

framed by the waiter's body on one side and his tray at the top. You might ask her to sit very still and use a slow shutter speed so that everyone but her blurs, something we will discuss in People in Action.

Settings—the Other Subject

The settings in which you make pictures of people are important because they add to the viewer's understanding of your subject. The room in which a person lives or works, their house, the city street they walk, the place in which they seek relaxation—whatever it is, the setting provides information about people and tells us something about their lives. Seek balance between subject and environment. Include enough of the setting to aid your image, but not so much that the subject is lost in it.

Sometimes the setting is what attracted you and made you want to make a photograph. In this case, it becomes the main subject, and the human figures become more of a compositional element. We are not so much interested in the people as individuals as we are in them as inhabitants of that space. If a monumental building has caught your eye, for example, you will probably find that its power is better communicated if the viewer sees it dwarfing humans at its base. You might see a wall plastered with posters and decide they are better shown with a person gazing at them.

Whether you are using the setting to tell the story of the person or using the person to tell the story of the setting, look carefully at everything in your viewfinder and ask: Does it help or hinder your intent? If it doesn't look and feel right, move. Just a few degrees to the left or right, or up or down, can make a dramatic difference.

Frames can be literal, (far left), or more subtle, such as the monks in the foreground (opposite, above). Using frames adds depth to the image and helps focus attention on the main subject.

Search for the angle that best communicates what you want to say about your subject. The image of surfers (opposite, middle) and the one of cowboys (opposite, bottom) wouldn't have been nearly as interesting if they'd been made from a standing position.

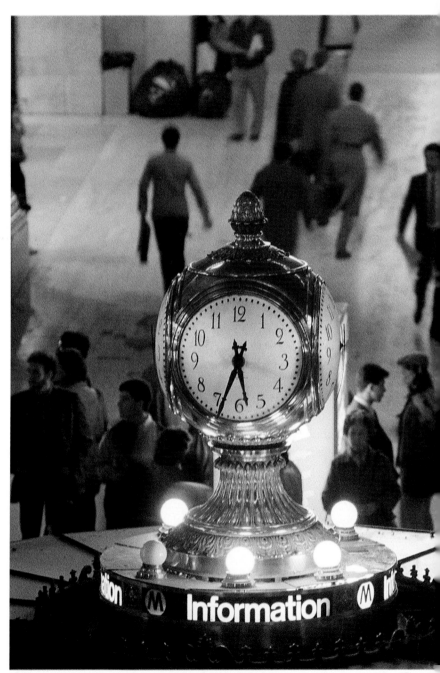

Find a scene, set up your composition, and wait for elements to come together. The

contrast of the clock and moving figures dramatically conveys the rush hour.

CAMERA BODIES, LENSES, film types, electronic flash, filters, tripods—all your photographic gear should be thought of as tools. Part of the craft element of photography is knowing your tools well and choosing the right one for the job at hand, just as a golfer knows which club to use for a particular lie and a mechanic knows which wrench is needed. The only way to know your tools is to work with them—a lot. There is no substitute for practice. You want the equipment and the technical aspects of photography to become so familiar that they are second nature, so that you don't have to waste a lot of precious time on them. Thinking about and composing your image are plenty to have on your mind.

Studio photographers and those who go on location with assistants often use medium- or large-format cameras because the larger film yields prints with finer grain, greater detail, and smoother overall tonality, and because they don't have to lug the stuff around.

The most common format, however, is 35mm, and the most popular 35mm camera for professionals and serious amateurs is the single-lens-reflex (SLR). These cameras and their lenses and accessories are easy to use, reasonably easy to carry around, and exceptionally versatile.

Our discussions in this book assume that you are using a 35mm SLR, but the principles apply to any format from point-and-shoot upwards, including digital cameras. Remember: Cameras

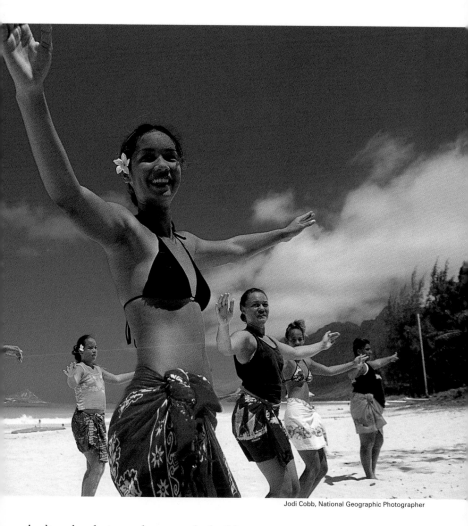

Jodi Cobb, National Geographic Photographer

don't make photographs—people do. It's not what kind of camera you have, but what you do with it.

It's important to choose a lens that is appropriate to the situation you are in. If you are making a head-and-shoulders portrait of someone, a short telephoto between 75mm and 135mm is usually the best, for reasons we will discuss in the chapter on Portraits.

If you are making environmental portraits or

A wide-angle lens, with its great depth of field, allowed the photographer to get all of the dancers in this scene in sharp focus, as well as a good view of the beach and the ship.

candids in a room, a wide-angle will probably be necessary so that you can include enough of the surroundings to convey a sense of place. If you are shooting out in the world, your choice of lens will be determined by a whole host of factors: how much of the scene you want to show, how close you can get to your subject, et cetera.

Because they have little control over events and often have to get their images in a hurry, most photojournalists today use wide-angle and telephoto zoom lenses. Except for special circumstances like sports, having these two lenses will enable you to cover just about any situation. The discussions of wide-angle and telephoto lenses that follow apply to both fixed focal length and to zooms.

Wide-Angle Lenses

Wide-angle lenses have the advantage of being able to include a lot of the scene, and they have quite a range of depth of field, as we've discussed. They are especially useful when working in small rooms or other tight places. But be wary of including too much within the frame and possibly weakening the impact of the picture. Always be conscious of what the center of interest (your subject) is, and use composition to lead your viewers' eyes to it.

Also remember that wide-angle lenses tend to make people look rounder than they really are and distort objects that are close to them— the wider the lens and the closer the object, the greater the distortion. Wide-angles also increase the apparent distance between objects in the frame, and make things—especially distant ones—seem smaller than they really are. You don't want your subject to be too small in the frame.

Tip

If you don't have a tripod and want to shoot with a long lens and slow shutter speed, use your camera bag to cradle the camera. If you're using a really slow speed, use a remote release or self-timer to avoid shake.

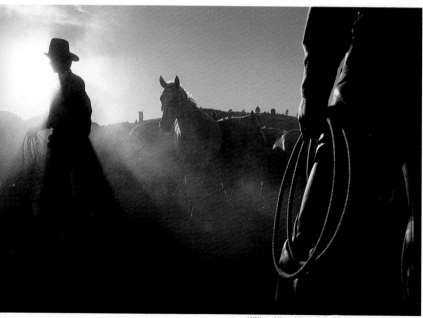

William Albert Allard, National Geographic Photographer

Great depth of field is crucial to all three of these images. Important elements in the compositions range from near to far, and the photographers wanted all of them in sharp focus. As you compose an image, think hard about what you want to be sharp and what you don't. If your camera has a depth-of-field preview button, use it to check before you click the shutter.

Robert Caputo (both)

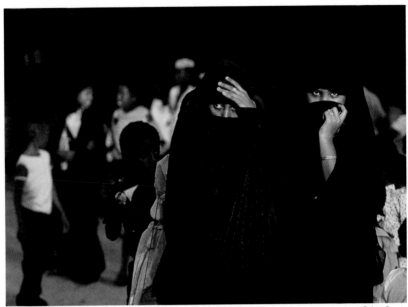

Robert Caputo

Telephoto lenses allow you to isolate your subjects from the background, as in this photograph of Muslim women. They were aware of being photographed, but did not mind if it was done from a distance. A normal or wide-angle lens would probably have made them nervous.

Telephoto Lenses

Telephotos have the opposite effect on people that wide-angle lenses do, making subjects appear a bit slimmer than they really are. They are good for portraits and of course for times when you cannot get physically close to your subject. Used at wider apertures, they have little depth of field, so be sure that everything you want to be sharp in your photograph will be. (Remember to use your camera's preview button to check this, if your camera has one.)

Telephoto lenses are great for isolating details and for covering a number of events, such as parades and rallies, where you are forced to work from fixed locations. Keep in mind that they also decrease the apparent distance between the objects in the frame (in effect compressing them), and will make things appear to be relatively larger.

Other Gear

There are, of course, many other pieces of equipment you can use. Tripods are useful for long lenses or long exposure times. Many photographers use hand-held exposure meters to avoid the problem of in-camera meters being fooled by a preponderance of bright or dark areas in the frame. Flash meters can measure electronic flash output. Graded neutral density filters can help tone down areas of excessive brightness, and colored filters can be used for effects. A range of electronic flash units, reflectors, lighting equipment, and modifiers can be used in the field or in the studio.

To learn more, and for technical information on film, digital cards, cameras, and other gear, look at the Web sites, magazines, and books listed at the back of this book.

By compressing the scene below with a telephoto lens, the photographer was able to communicate the boisterous fun and a sense of how crowded the water was. Using a longer or shorter lens would have sacrificed one of those impressions.

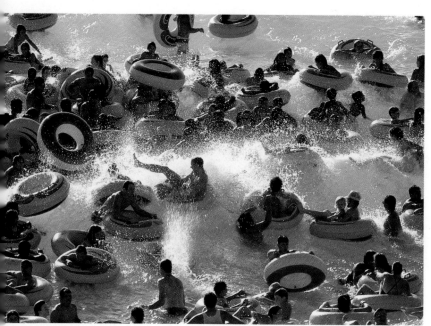

Jodi Cobb, National Geographic Photographer

IT'S ALL ABOUT LIGHT. The word photography means light drawing, and that is exactly what you're doing when you make a picture—drawing with light on a piece of film or digital card. There are two aspects you need to think about when you look at the light that is falling on a scene you want to photograph, or the light you add with an electronic flash or any other source: quality and direction.

By quality of light we mean both the color temperature and the strength. The color temperature of light determines how the colors of the objects you are photographing will be rendered by the film or digital card. The same object photographed with daylight-balanced film will look different if lit by the sun in one frame and by a table lamp in another. In fact, it will look quite different if lit by the sun at noon and just before sunset. When the sun is low, either in the morning or afternoon, its rays are longer and contain more of the red, or warm, end of the color spectrum. The lower the sun, the longer the rays. That's why sunsets and sunrises are red. Photographs made when the sun is low look warmer, which we normally perceive to be more pleasing and flattering than the bluer light of midday. It's one of the reasons we usually prefer almost any kind of picture—landscapes, people, wildlife—made early or late in the day.

The other part of quality of light is its strength. On a clear day, sunlight hits objects

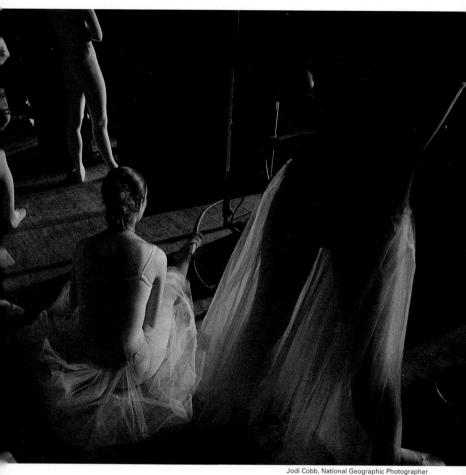

Jodi Cobb, National Geographic Photographer

directly. On a cloudy one, it is diffused. If you're using electronic flash, photo lights, or some other light source, you can aim it straight at the subject or diffuse it by using a softener of some sort or by bouncing it. The strength of the light falling on the subject has an effect on the way its color will be reproduced and, of course, on the shadows or lack of shadows.

Another reason we find photographs made early or late in the day pleasing is that the angle of the sun makes long shadows then, creating

In this image, the photographer used the light coming through the stage door to give dramatic definition to the ballet dancers' forms and diaphanous skirts and also to reinforce the sense of anticipation before the performance begins.

Robert Caputo

The low angle of the late sun creates a dramatic shadow in this side-lit photograph. When shooting outdoors on sunny days, always take note of how the shadows are falling. If you can, use them in your compositions.

contour, or what photographers call modeling.

And that's where direction comes in. The rule of thumb is generally to make photographs with the sun (or other light source) coming from over one of your shoulders, at about a 45° angle to the subject. In this way, the subject's features—the nose, for example—will cast shadows on one side, lending three-dimensionality to your two-dimensional image.

If the sun is directly overhead, it will cast shadows, but ones you probably don't want. Usually you get big black blobs in the eye sockets and under the nose and chin. If the person is wearing a hat, you might not see the face at all.

The best way to learn how quality and direction of light affect photographs is a simple exercise. Take a friend into your front yard and make portraits of him early in the morning and at midday on sunny and cloudy days. On the sunny morning, make images with the sun at 45°, 90°, 180°, and one straight on. Then look at the

images to see how the direction and quality of the light have affected both the colors and the feeling. Again, look at photographs in books and magazines. When you see pictures that really strike you, stop and analyze them—what kind of light was it, where was it coming from? Why did it work so well for this image?

In this chapter we will discuss how to use and modify the quality and direction of light. As with everything else in this book, these are guidelines, not hard and fast rules. Break them if that's what works. Practice techniques as often and in as many different situations as you can. You want the technical parts of photography to become second nature so that you don't have to waste valuable thinking time on them.

A few words about bracketing: I recommend bracketing exposures in almost any situation you are photographing, especially ones with tricky lighting. If you have bought cameras, lenses, and film and gone to all the trouble getting somewhere to make photographs, the expense of a little extra film is not much. Negative films have quite a lot of latitude—they can be off by a stop or more and still yield perfectly good prints. Transparency film is less tolerant— you have to be right on if you want to get good color rendition and detail.

Cameras are mechanical things—they have their quirks. You may set your shutter to 1/250 of a second, but it will almost certainly not be open for exactly that amount of time—1/200 or 1/300 is more likely, and it could be off by even more. By bracketing you can overcome this. You should make one exposure at the shutter speed/aperture combination you think is right, then make one a half stop under and another a half stop over. If it is a really tricky situation, bracket several stops up and down to be sure.

Tip

Don't just stand there—sit, squat, lie down. The angle from which you make a photograph can make a dramatic difference.

Indoor Light

Window Light

The light coming through a window can be harsh or soft depending on whether the sun is shining or reflecting through. It may be enough to light up the whole room, or you may have to add light. If you are photographing in a room with windows, try to visit it at different times of day to see how it looks and to figure out when you want to shoot.

The shaft of light: If you want to photograph a room lit by a shaft of light and want the shaft visible, measure the strength of the light in the shaft and then measure the light in other parts of the room. If there is too much difference, the film or digital card will not be able to record both. You probably want to add light to the rest of the room—either with an electronic flash or by turning on the lamps or other lights. Be careful not to overpower or even equal the shaft of

Sunlight streaming through the windows creates a beautiful background in this image of young monks in training. In situations with such high contrast, you may need to use fill flash to get detail in the subjects' faces, as the photographer has done here.

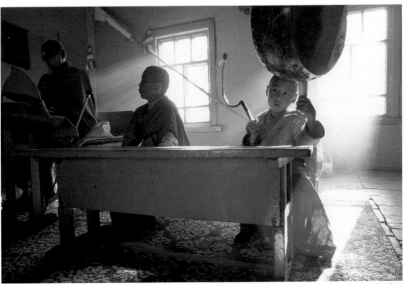

James L. Stanfield

Robert Caputo (both)

The images above were lit solely with a ray of sunshine coming through the roof of the Buddhist temple. Look for the way sunlight is reflected by objects in the room—the monk's face (right) is illuminated by light bouncing off the book. Such situations with a preponderance of dark areas require careful metering.

light. If you're using a single on-camera electronic flash, bounce the light off the ceiling or a wall. Expose properly for the light in the shaft and then set your flash unit to underexpose by a stop or more. If you raise a little dust or blow smoke into it, the shaft will really stand out.

The natural light coming in through a window is perfect for portraits. Pose your subject next to the window so that three-quarters of his or her face is lit. The side away from the window will be in shadow. If you think the shadow is too deep, use a reflector to bounce a bit of light into the face to soften it. There are commercially made reflectors, but you can also use a piece of white construction paper, a sheet, or just about anything white. By moving the reflector closer to or farther from your subject you can control the amount of light bounced onto the face.

If the light coming through the window is too strong, you can soften it by placing thin curtains, a white sheet, or tracing paper over it. If it's a cloudy day but you really want a shaft of light coming through the window, put an electronic flash outside and aim it into the room.

Tip

Create a catch-light in the subject's eyes with a small reflector, such as a dulled mirror or the silver side of a CD, to add a bit of glimmer.

Fixed Electronic Flash, Photo Lights, and Reflectors

If you are working in a studio or in a room with little or no light, you need to add it. In this section I will talk about using lights in a studio, but the same principles apply to any room where you can set up off-camera lights.

The standard way to light a portrait is to place your main light (called the key light) at a 45° angle to the subject. This emulates the sun over your shoulder. Soften the light by bouncing it into a photographic umbrella or with a softbox or some sort of diffusion material—a white sheet or piece of tracing paper placed over the light will do. To make the shadows on your subject's face longer, move the key light to the side. To make them shorter, move it toward the front.

Unless you want harsh shadows, you should use fill light or a reflector to throw a bit of light into the shadow area. How much depends on how strong you want the shadows to be. Move the fill light or reflector toward or away from your subject to strengthen or weaken its effect.

The same basic setup can be used for lighting a room for an environmental portrait. You just need to cover a wider area. Since light falls off geometrically in proportion to distance, you may need stronger lights or faster film.

Tip

When using an electronic flash indoors, move your subject away from walls to prevent harsh shadows.

By using a combination of window light and fill flash, the photographer was able to soften the shadows on the left side of each subject's face and have enough depth of field to have their features all in sharp focus.

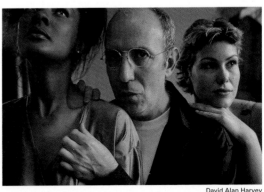

David Alan Harvey

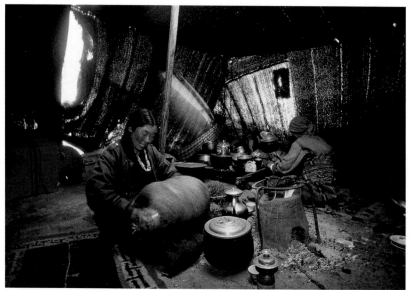

Robert Caputo

Using More Than One Light

You can, of course, use as many lights as you like, and there are all sorts of ways of doing this. If you are shooting in a room, you can use its lamps and overhead lights. If they are not strong enough, put photo bulbs in them. Or you can use photo lights or electronic flash to light up a corner of the room you want detail in. If you want to do this with an electronic flash, put a slave on it, and hide it in the area of the room you want to illuminate. (A slave is a trigger that fires a remote electronic flash by responding either to light or a radio signal.) Think about how you want the room to look, what parts of it you want fully lit, and set up lights accordingly. Use your imagination, but don't over-light. People and rooms seldom look their best if they are evenly lit and flat.

In the studio, you may want to go beyond the basic portrait setup—lighting the background or backlighting the person's hair, for example.

Think about how strong you want your electronic flash to be. In this image, it was important to see the light coming through the woven fabric of the tent, so I used a slow shutter speed and set the flash unit to under-expose a bit. Full flash at a fast shutter speed would have overpowered the sunlight.

To light the background, simply aim a light at it. But think about how bright you want it to be. If you want it to be the same as the light on your subject, balance the intensity with your key light. If you want it brighter or darker, set the intensity to achieve this. You can also add color to the background if you are shooting against a scrim or something else plain. Put a blue filter over the light if you want a blue background, et cetera.

To backlight a person's hair, place a light slightly to one side behind and above them. Fit the light with a snoot, an attachment that looks like a tube and narrows the light beam, and aim it at your subject's hair. Or you can place the light low and directly behind your subject so that it is hidden from the camera.

Using Mobile Electronic Flash

If you are making candid shots—while traveling, as part of a photo essay, or even at home—you probably don't want to be burdened with cases full of electronic flash units, light stands, soft boxes, umbrellas, battery packs, slaves, and all the other paraphernalia we've been discussing so far. With today's sophisticated electronic flashes and high-quality fast films, you don't need to. You can often get enough light out of one electronic flash to light a small room, or you can use the blur/freeze technique we will discuss in People in Action. At very slow shutter speeds, even dim lights in a room will cast enough light to be recordable.

Full head-on light from an on-camera electronic flash usually doesn't look very pleasing. It is quite harsh and casts strong shadows behind your subject. The best way to use an electronic flash is to fit it with some sort of diffusion accessory. Some of these are opaque plastic domes that fit over the top of the electronic flash, some

Tip

To create a pleasing lighting ratio, use a flash meter to determine if the key light is twice as bright as the fill light.

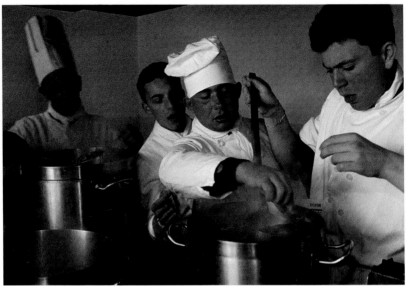

William Albert Allard, National Geographic Photographer

are white plastic and function as a small reflector. You can even use a bit of white cardboard taped to the top of the electronic flash and bent so that it reflects the light forward. You should try different kinds to see which you like best.

If you don't have a diffusion accessory, you can accomplish much the same effect by bouncing the flash off the ceiling or a wall. Simply point the electronic flash straight up or, even better, twist it to point at a nearby (preferably white) wall. This will not work, though, if the ceiling is too high or the wall is too far away.

Another way to shoot with a mobile electronic flash is to get a cord that links the flash with the camera. Then you or a friend can hold the flash off to one side so that the light gives more modeling. You can also use remote electronic flash units set up with slaves. Hide them in various parts of the room, and they will fire when they sense that your on- or off-camera electronic flash has gone off.

Working in a kitchen or any other busy, crowded place usually precludes setting up fixed lights. Use a diffusion device and set your electronic flash slightly under the proper exposure for the room to get an image like this one, in which the use of flash is not noticeable.

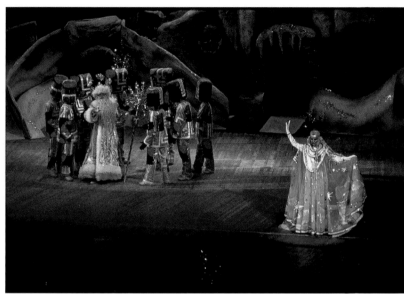

Cary Wolinsky

Stage light is usually tungsten, so use tungsten-balanced film for proper color rendition. Performances are often dimly lit, so you may need a fast film. If you use a telephoto lens (above), rest your camera on a railing or a seat back. If only the performer is lit (right), use a spot meter mode (if your camera has one), to get a reading.

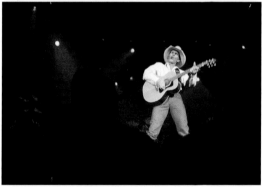

William Albert Allard, National Geographic Photographer

Stage Light

If you are shooting a play or a concert, you will probably be dealing with tungsten light, which is quite a bit warmer than sunlight. To get accurate skin tones and color rendition, use a tungsten-balanced film. When using a digital camera, it is important that the white balance the camera is set for matches the light source. Check your camera manual for instructions on changing

white balance, and use the proper setting when you want a natural look. The stage may be lit by all sorts of colored lights during the perform-ance, so be aware of them and how they will affect your photographs.

You may need a fast lens and fast film to shoot some stage performances. Many are dimly lit for effect (unless they are being televised, in which case there will be plenty of light). If you can, go to a rehearsal so you can measure the light and know what you will have to deal with. If you want to freeze the action—of dancers, say—you'll need a fairly fast shutter speed.

The same holds true for nighttime sporting events or any other activity that you are not lighting yourself. Think about the event you are photographing. If it's a professional sports game, it will almost certainly be lit for television and newspaper photographers, and you can use their light. If it's a nighttime Little League game, it probably won't be.

The warmth of candlelight gives a rich yellow cast to the images below. The number of candles gave off enough light to enable the photographer to make images at about 1/30 of a second. Wherever you are shooting, always be on the lookout for vivid details that help tell the story, as with the image at right.

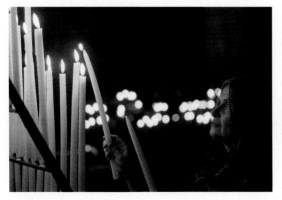
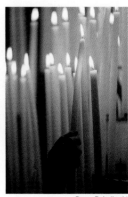

Bruce Dale (both)

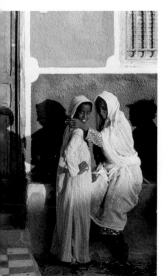

Robert Caputo

Bright sunshine and strong shadows set a dramatic mood for this photograph and highlight this girl's friendly smile. Notice how the composition makes use of the blocks of color in the background.

Outdoor Light

Time of Day and the Weather

As we mentioned in the beginning of this chapter, natural light changes in quality and direction throughout the day and also, of course, with the weather. Sunlight generally looks better to us early and late in the day because of its warmer tone and the longer shadows. It even looks different on different kinds of cloudy days—some diffuse sunlight can still be pretty harsh, while some can be extremely soft and yield gorgeous color saturation on the film.

The important thing is to think about your subject and what sort of light you think would suit him or her best. If you are shooting a model on a beach, you probably want a nice sunny day. But you may not want to shoot a tornado chaser on one. Use the weather and the time of day to help reinforce the message of the photograph. The model lying in the surf on a sunny day will look best when the warm light of late afternoon makes the ocean a deep blue, the sand a rich, warm white, and the long shadows give modeling to her and the ripples in the sand.

But are these also the qualities you would want for shooting a prospector trudging across the desert? Probably not. There you might want to use the harsh sunlight of noon. The colder color and the intensity of the light would help you convey the sense of heat, as would the deep vertical shadows. To make this idea even stronger, move away from him and use a long telephoto so that you can see the heat waves rising from the ground.

Always remember that a photograph is an idea expressed. Think about what you want the photograph to say, what your idea is. Think about how the light falls at different times of day

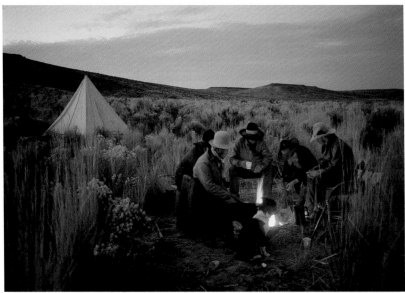

William Albert Allard, National Geographic Photographer

Shooting in low light requires a steady hand. In the image above, keeping the cowboys in focus and lit by the campfire's glow required shooting at 1/30 of a second. Below, the great depth of field inherent in wide-angle lenses made it possible to keep foreground and background subjects sharp despite low light.

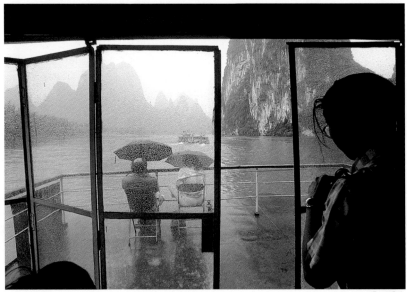

Bruce Dale

on the location you are working in—its direction, the length of shadows it casts, and its color quality. Then choose the time of day and the weather that are appropriate. Don't hesitate to get out there in rain, storms, or other inclement weather if that's what's best for your images.

Open Shade

There may be times when you can't wait for the optimal time of day or weather. As often happens in the world of photojournalism, you have to make the best of what you have to work with. If you are somewhere in the middle of the day and the sunlight is bright—and if you've decided that's not the kind of light you want—be on the lookout for open shade.

Photographs made in open shade look much like ones made in diffuse sunlight. The lighting is fairly even and soft. Open shade can be created by a number of things: awnings, doorways, and trees, for example. If you are walking around a city or town, look especially for open shade across the street from a light-colored wall lit by the sun. The light bounced off the wall will illuminate everything across from it, often with

Open shade creates tricky metering problems, especially if your subject is in a doorway or window. Light falls off fast, in just a few inches, and the subject may be surrounded in black. Use the spot meter mode if you have one, and bracket to be sure of getting the right exposure.

Robert Caputo

very beautiful light. Light bouncing off a sidewalk often gives a dramatic lit-from-below look.

If you are shooting in the shade created by a tree or other free-standing object, be mindful of how bright the background is. If it is fully sunlit, it may create too much contrast for the film or digital card to handle.

If you are making an outdoor portrait and don't have the natural light you want, pose your subject in open shade, preferably in a setting that has something to do with the message you are trying to convey. If there's no open shade around, you can create your own by hanging a sheet or something similar.

Be aware that the strength of light falls off very quickly. If you're shooting someone in open shade in a doorway, for example, have him stand right at the edge. If he takes a step back, there may not be enough light.

Fill Flash and Reflectors

Another way you can deal with less-than-optimal light is to add some of your own by using fill flash or reflectors. With either one, the principle is the same—you are throwing a little light onto the subject to soften the contrast and lighten up the shadows.

If, for example, you are making a portrait of someone wearing a hat, you may see that the shadow cast by the brim is so dark that the film or digital card will not be able to record any details in his face. By throwing a little light into his face, you can overcome this. You don't want to equal or overpower the natural light, though, because then you would lose the shadow altogether. You want the shadow *and* the detail.

Using fill flash is fairly easy because electronic flash units read how much light they are emitting and they communicate with the camera. All

Tip

A piece of very light orange gel over the face of your electronic flash can warm up the light and give it a more pleasing cast.

you have to do is indicate how much light you want them to throw.

Put a dome or other diffusion accessory on your electronic flash, set it one click-stop up from horizontal, and then program it to throw out the amount of light you want. A good rule of thumb for most fill-flash situations is to set the flash to one or one and a third stops under. Set the camera for a normal exposure and fire away. The flash will read what the camera is set at and emit one stop less light. For example, if the meter reading for the scene is f/8 at 1/250 of a second, set the camera at those settings. If you've programmed the flash to be a stop under, it will throw out light for f/5.6, reducing the contrast but not overpowering the sunlight. When fill flash is done well, you can't even see that it was used. Using reflectors is essentially the same, with the advantage that you can see the effect of the light you are bouncing onto the subject.

The dramatic backlight in this image captures the moment the man enters the room. Notice how the photographer's composition includes patterns of light and shadow on the wall and table and how the light on the table and rays of light on the floor lead your eyes to him.

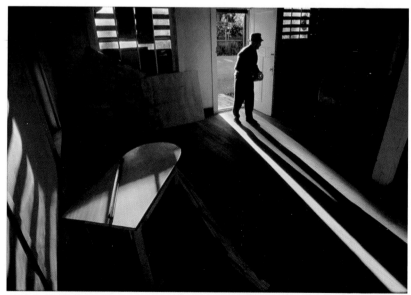

Richard Olsenius

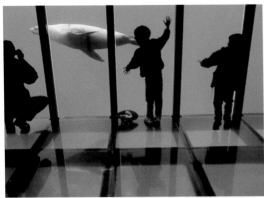

Annie Griffiths Belt

As this photograph taken at an aquarium shows, silhouettes can be made anywhere the contrast between subject and background is great.

Backlighting and Silhouettes

Backlighting, whether indoors using artificial lights or outdoors using natural light, serves to separate your subject from the background and can often be very dramatic. The amount of backlight and its relationship to the amount of light falling on the front of your subject determines whether you see detail in it or it is rendered as a silhouette.

Indoors

We talked about using an extra light to backlight your subject's hair in the section about using more than one light. The stronger you make that light, the more of a halo effect you will get around the person's head.

You can also backlight the entire person by aiming a light at him from behind, making sure that it is hidden from the camera. Be sure, though, that you are throwing enough light on your subject from the front to still see detail. If you want to shoot a person in silhouette indoors, simply light the background strongly and don't throw any light on your subject. Expose for the light on the background.

Tip

If you do a lot of flash or fill flash photography, use a battery pack for your electronic flash unit. It stores considerably more power than the AAs used in most units. You'll get a lot more flashes and you won't have to wait as long for the flash to recycle.

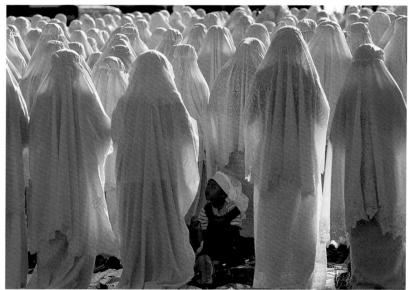

Robert Caputo

Don't be afraid to shoot against the light. By shooting these women from behind, the fine quality of their garments was highlighted in a way that would be impossible from the front. It also reinforced the idea of veiled women and the idea of anonymity.

Outdoors

Backlighting can also be used to great effect outdoors, so don't be afraid to shoot against the sun. You can use it to highlight a person's hair as you would in an indoor portrait, or you can use it so that a person's shadow is stretching dramatically toward the camera. Think about what you want to say, and use the light that says it.

If you are shooting people on a bright beach or against any other bright background, they may be backlit. If they are, be conscious of the contrast between the light on the front of your subject and that coming from behind. If the contrast is great and you want detail in your subject, use fill flash or a reflector as discussed.

If you want a silhouette, expose for the background, but be careful if you are using an in-camera meter and the silhouetted person is large in the frame. All that dark area will probably fool the meter. Take a reading from the background, then recompose for the shot.

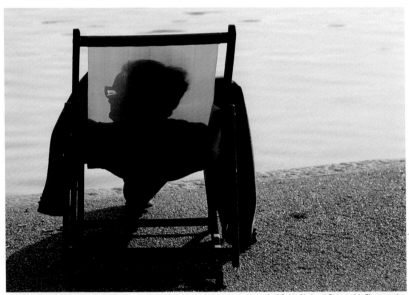

Jodi Cobb, National Geographic Photographer

Jonathan Blair

Robert Caputo

Keep your eyes open and be patient. For the image at the top, the photographer spotted the situation while walking around a park, then waited for the man to turn his head to get the silhouette she wanted. With a fast shutter speed, backlit rain or water from a shower can be frozen in motion (above, left).When shooting against the sun (above, right), wait for the moment when it is masked by something in the frame, such as these dancers, so that the picture is not overwhelmed with light.

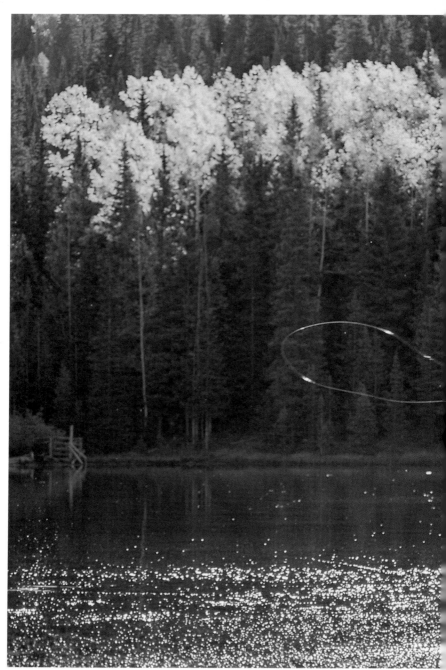

Backlighting makes the fishing lines stand out against the dark woods and captures

Robert Caputo

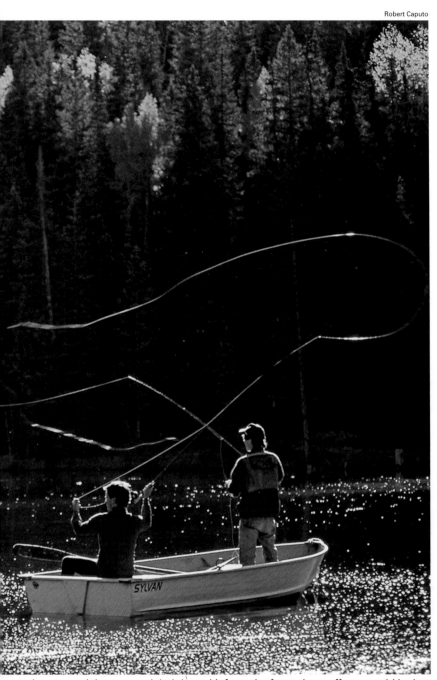

a glow around the men and their boat. Lit from the front, these effects would be lost.

IT'S FAIRLY EASY to make photographs of people we know—we feel comfortable with them and there is mutual trust. We don't hesitate to ask them to smile, or stand over here, or turn a certain way. Making pictures of strangers, though, is more difficult, and one of the hardest things to do is to overcome our shyness.

It's all about attitude. The old adage that a dog can sense when someone is afraid of it applies in a way to photographing strangers. If you feel shy and insecure, the people you want to photograph will sense it. If you are nervous, they will be nervous. If you are sneaking around, they will think that you are up to something sneaky and feel that they are being used. If, however, you are friendly, open, and engaging, most people will respond in a similar way and be happy to indulge you. If you approach them in the right way, they will be flattered and ready to cooperate. Making a photograph is, after all, a cooperative venture between you and the subjects, whether they are aware of it or not.

There are exceptions, of course. Some people just don't like to have their picture made. In some cultures it is against custom to make images of certain groups of people or even anyone at all. Always respect another person's wishes and customs. Learn about local mores if you are traveling, and be receptive to the way people respond to you when you raise your camera.

Most often, the best way to make street pho-

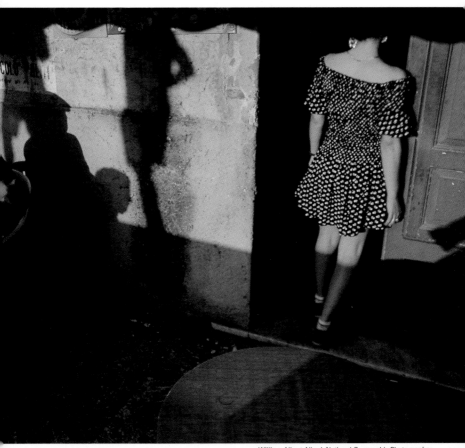

William Albert Allard, National Geographic Photographer

tographs is to wander around. Get lost in a new town and be open to all the life and relationships that pass before you. When something or someone catches your eye, take a closer look. Think of ways to capture the feeling that made you stop.

For street photography, think carefully about what gear to carry. Take enough to cover any situation you might come across, but not so much that you're burdened. A basic kit would include: a body, a 17-35mm f/2.8 zoom, an 80-200 f/2.8 zoom, an 85mm f/1.8, an electronic flash, and plenty of film or digital cards.

When you find a good situation, hang around and be ready. Drawn to this scene because of the light and shadows, the photographer was prepared to shoot when he saw the woman approach the doorway.

Robert Caputo

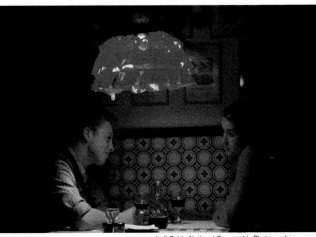

Jodi Cobb, National Geographic Photographer

Shooting unobserved candids is not difficult if subjects are absorbed in something. A telephoto lens framed the scene in a café without disturbing the woman reading (above, left). In bars and cafés, people are often so engrossed in conversation (above, right) that they are unaware of the camera.

Candids: Being Unobtrusive

You may want to make photographs of people going about their business—vendors in a market, a crowd at a sports event, the line at a theater. You don't want them to appear aware of the camera. Many times people will see you, then ignore you because they have to concentrate on what they are doing. You want the viewers of the image to feel that they are getting an unguarded, fly-on-the-wall glimpse into the scene.

There are several ways to be unobtrusive. The first thing, of course, is to determine what you want to photograph. Perhaps you see a stall in a market that is particularly colorful, a park bench in a beautiful setting—whatever has attracted you. Find a place to sit or stand that gives you a good view of the scene, take up residence there,

and wait for the elements to come together in a way that will make your image.

If you're using a long lens and are some distance from your subject, it will probably be a while before the people in the scene notice you. You should be able to compose your image and get your shot before this happens. When they do notice you, smile and wave. There's a difference between being unobtrusive and unfriendly.

Another way to be unobtrusive is to be there long enough so that people stop paying attention to you. If you are sitting at a café, order some coffee and wait. As other patrons become engrossed in conversations or the paper, calmly lift the camera to your eye and make your exposure. In most cases, people either won't notice or won't mind. But be judicious. Don't keep firing away and become a nuisance. Then they *will* mind. You can also set the camera on the table with a wide-angle lens pointed at your subject and simply press the remote release when the time is right. Modern auto focus and auto exposure cameras make this easy to do well.

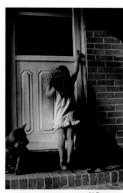

Al Petteway

This image conveys great warmth because it was taken just as the girl stood on tiptoes to reach the doorknob. Always watch the action as it unfolds in your viewfinder, and wait for the right moment.

The Decisive Moment

Photographs capture an image of the world at a moment in time; the trick is to get the right one. A good photograph captures the essence of a situation. Henri Cartier-Bresson came up with the term "the decisive moment" to describe that one moment seized from the flux of time that best captures what an artist wants to say with a camera. It is the instant when the graphic, emotional, and intellectual elements all come together to produce a good image. Getting it takes patience, awareness, thought, and practice.

In a portrait, the moment can be seen in the person's expression. In a street scene, it's a combination of human expressions and the physical

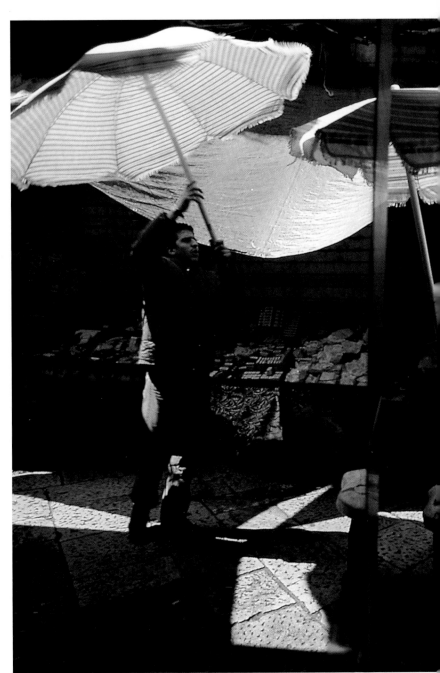

Noticing a mirror and the reflection of a man as he put up an umbrella, the photog-

William Albert Allard, National Geographic Photographer

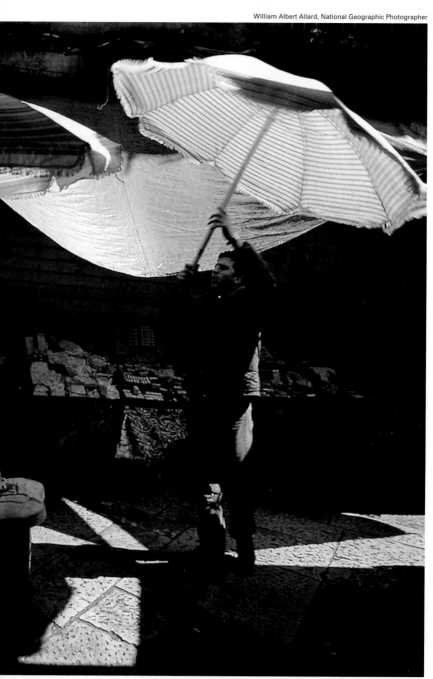

rapher positioned himself so he could capture the scene's near-perfect symmetry.

and emotional relationships people have with each other and the environment, the shadows and light—everything that is in the frame.

With sports, the decisive moment is usually pretty clear—it's just when the high-jumper clears the bar, just when the baseball touches the cone of the fielder's glove on a diving catch. When you're photographing two people, the decisive moment will most likely come when their facial expressions and body language reveal their relationship: the kid staring in awe at the ball player, the young man presenting a corsage to his prom date. In street scenes, the moment will usually be less obvious because many more elements are involved.

Let's say you've seen an interesting wall in a town somewhere. The wall's color and the windows and doors appeal to you and make you want to make a photograph. But something is missing. The scene seems to need a human form to make it complete. You take up a position that allows you to frame the wall just as you like and decide exactly where in the frame you want the person. Then you wait. A person passes through the frame, but too close to you. Another one passes, but her clothes are the wrong color. A third goes through in the wrong direction. The next person sees you and stops, not wanting to interfere with your photograph. Finally, a person passes though the frame at the right distance, going the right way, dressed in colors that complement the wall. When he gets to the predetermined spot, you have your moment.

When a scene involves many people, a large area, different kinds of light—as street scenes often do—capturing a visually interesting and telling moment requires a lot of thought, time, and patience. Look at the work of photojournalists to see how they have done it. And practice.

Tip

Be patient. Street scenes change by the millisecond. Find a spot you like, get comfortable, and wait, watching all the time for the elements to fall together.

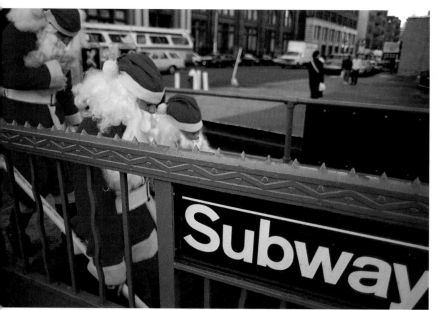

Jodi Cobb, National Geographic Photographer

Anticipating Behavior

To capture the decisive moment, you usually have to be able to predict behavior. A good sports photographer can anticipate when a basketball player is about to shoot. A good wildlife photographer knows when a leopard is about to pounce—that's how they get images of the ball leaving the fingertips and the leopard in mid-air.

An important element in people photography is knowing your subjects well enough to be able to anticipate what they are going to do. It's the only way you are going to be able to get pictures of it. If you wait until you see it, it's too late.

The key is to watch people carefully. Always have your camera ready. If you're going to be shooting in one situation, set the aperture and shutter speed in advance so you don't have to fiddle with them while you're shooting. Watch people through the viewfinder. If you're paying attention, you'll sense what's about to happen.

Always think about what your subjects might do. The photographer, shooting street scenes in New York, observed that a group of Santa Clauses was headed for a subway stop and ran ahead to get the image above.

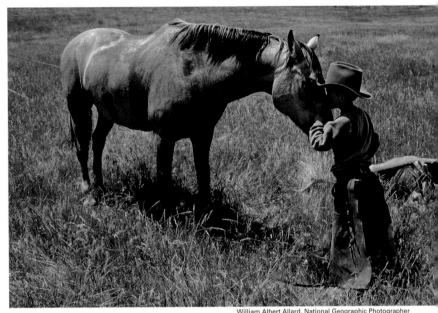

William Albert Allard, National Geographic Photographer

When photographing people interacting with each other or with pets, observe their behavior and think about what they might do to express the essence of the relationship. By waiting for the scene to evolve, the photographer was able to get this moment between a young cowboy and his horse.

Predicting Relationships Within the Frame

A great deal of people photography is understanding human nature and being aware of how people usually react in given situations. If someone is sitting in a café, he will usually look up when the waiter approaches. People will generally smile when they see a baby or open a present. Crowds rise when a batter smashes a ball that looks like it's headed for the seats. Think about the situation you are photographing and how people are likely to act in it. Then prepare yourself for the moment.

If the people in a scene are moving, look ahead of them to compose the image so you will be ready when they move into it. If two people are about to greet each other, try to predict where they will meet so you can capture the handshake or embrace.

It's not just predicting how people will interact with each other, though. You also have to be

able to anticipate both the emotional and graphic relationships between the people and everything else in the scene—the buildings, artifacts, areas of light and shadow.

Again, think about the feeling you get from the scene. What appeals to you? If you want to photograph the Lincoln Memorial, for example, decide what you want to say about it. If the monumentality of the building impresses you, look for the way it dwarfs the human figures who look like mere graphic elements at its base. If, however, you are after the inspirational aspect of the building, go inside to photograph the look of admiration on someone's face as he gazes up at Lincoln's statue.

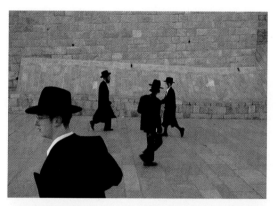

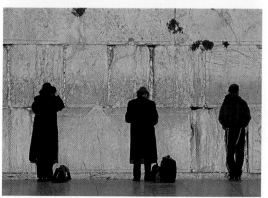

The photographer knew that people prayed at the Wailing Wall in Jerusalem (left, below), but wanted to get something different. By standing back, using a wide-angle lens, and waiting as people came and went through her frame, she was able to capture the moment (left, above).

Annie Griffiths Belt (both)

Annie Griffiths Belt

Look for patterns and the one element that breaks them. By using telephoto lenses, the photographers of both of these images were able to isolate the patterns inherent in their subjects and reinforce them by including something different. Notice, too, that both have placed the contrasting element off-center.

Robert Caputo

Using Patterns

Patterns, lines, and other graphic elements can enhance the message and mood a photograph conveys, or they can be the subject of the image. Whenever you are walking down a street, through a market, or along a beach, keep an eye out for patterns.

Repetition is usually the most obvious (and most photographed) pattern, so look for repeating shapes, colors, or other graphic elements. But don't just look for things—look for patterns of shadows and light too.

You can use patterns to guide the viewer's eyes to your subject, as we discussed earlier. You can make your subject stand out by being the one that is different from the rest of the pattern—the one who stands out in a crowd. Or you can use the shapes of the human beings within the frame as a pattern of their own.

Tip

While looking through your telephoto lens, scan around the scene looking for patterns. If it is a zoom, try different focal lengths.

Candids With Consent

Unobtrusive candids seek to be fly-on-the-wall images that catch people going about their business seemingly unaware of the camera and the photographer. This yields images that are more toward the objective end of the objective/subjective continuum, though there is not, of course, any photograph made by a human that is completely objective. Candids with consent, made when the photographer is actively engaged with the subject and the subject is conscious of this involvement, are very different.

Photographs are records of the photographer's relationship with his or her subject. In consensual candids, the relationship can be either obvious (the subject looks directly into the camera) or subtle—the relationship is implied because the image feels more intimate. We sense that the photographer was physically

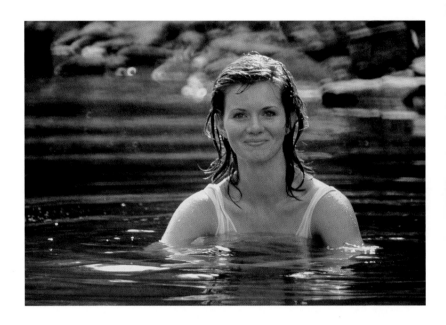

close to the subject and that the person was aware of being photographed.

Engaging Your Subject

The first order of business is to engage your subject. This is where we all have to learn to overcome our shyness and approach people in an open and friendly manner. Be up front about who you are and what you're doing.

Don't just barge into a scene with your cameras blazing. In fact, it is usually best to leave your camera in its bag when you first approach people, so as not to frighten them. Take time to engage the person in conversation, just as you would if you didn't have a camera.

There is a reason that this person or group of people arrested your attention and made you want to photograph them, so you are already curious about them and what they are doing. Express your curiosity. Almost everyone is flattered when someone shows a genuine interest

in them, and you will find most people very willing to talk. Before long, you can get around to asking if you can make some pictures. If you approach your subject in the right way, few people will refuse.

If you are pressed for time, or if the person is busy with something else, get straight to the point with something like, "That's the biggest pumpkin I've ever seen." Briefly explain what you want to do and why. If the person refuses, move on—there are lots of other subjects out there. If photographs are records of relationships, you aren't going to get very good pictures of people who don't want you to take them.

A photograph is a record of the relationship between the subject and the photographer. Both of these images work well because the subjects—the friendly woman and the shy girl—are directly engaged with the photographer, and therefore with us, the viewers. These responses are only possible if you are friendly and engaging.

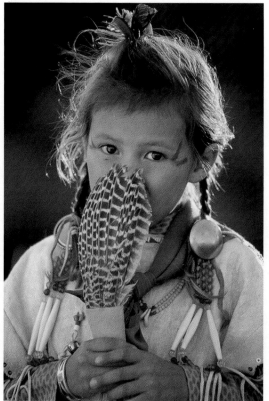

Bruce Dale (both)

Remember the Golden Rule. Think about how you'd feel if someone approached you and wanted to make a photograph. How they did it would determine how you would respond.

Once you have permission, it's up to you to determine just how involved in the scene you want to be. Do you want to stand at the edge of a crowd and photograph a group of dancers, or do you want to get right in there with them? Do you want to make images of a passing parade or march with it? A hint: People often respond to photographers better when they see that they are willing to make fools of themselves, too.

Once you have access to a situation, make the most of it. Most situations are complex and have an infinite number of picture possibilities. Think carefully about the aspects you want to show, and don't give up until you have them. These three images are only a few the photographer made of this ballet troupe.

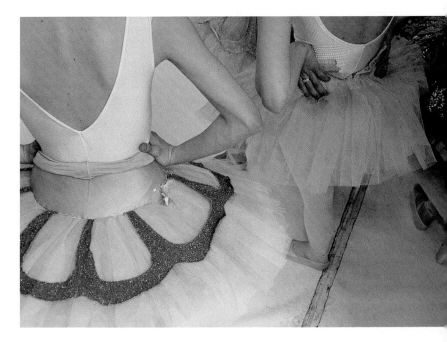

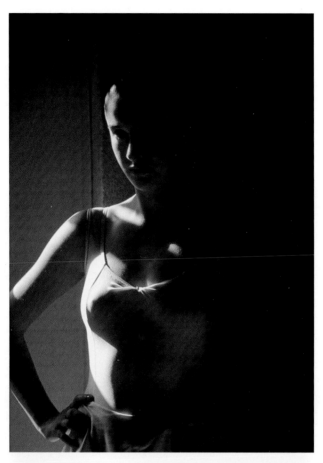

William Albert Allard, National Geographic Photographer (all)

Portraits of people from other cultures have to do double duty—they have to be honest about the exotic nature of the people while conveying our common humanity. Because of the man's smile and the direct gaze of the child, this image captures both.

Approaching Unfamiliar Cultures

One of the keys to success in photographing cultures different from your own is doing as much research as you can before you go. Talk to people who have been there and get their recommendations. Find out if there are any taboos about photography, and if so, what they are.

Another key to success is to be sensitive to local customs and the different reactions people may have to you and your camera. Learn a few simple phrases in the local language so you can at least say hello to people and ask if you can make photographs of them.

Some people have no problems with photography, and you should treat them in the same courteous and respectful way you would treat people at home, by engaging them and seeking their permission. Others have objections to photographs being made of certain individuals or groups.

Some people object on religious grounds. Some feel that you want to make fun of them, to show their poverty or some other aspect of their lives to the world. Other people believe that when you make an image of them you are stealing their soul or in some other way taking something away from them.

They are right, of course. Photographers talk about capturing the essence or spirit of a person or place. We do take something, and we profit by the taking. You should always respect people's feelings and beliefs. There are selfish reasons for this—you don't want to be beaten up or thrown in jail. But the main point is that people are always more important than photographs. You don't want to abuse people, and doing something against a strongly held belief is abuse. And the photographs would probably not be very good anyway.

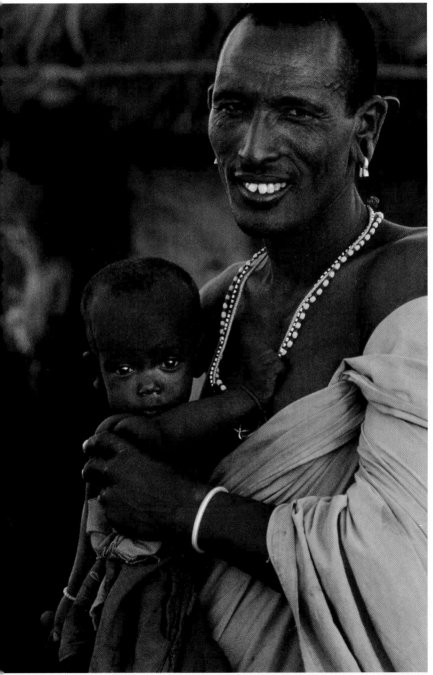

Robert Caputo

When photographing other cultures, be as friendly and courteous as you would be at home. The girl above was happy to be photographed because I had spent time with her, slowly introducing the camera. The image below was made with a 300mm lens because I did not want to disturb the woman or the dog.

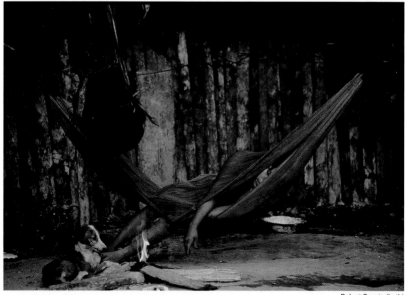

Robert Caputo (both)

There are ways around taboos. If you spend enough time with people, you will often find that they will be willing, under certain circumstances, to let you make photographs—if they like you.

I once spent several days in a village where the people were devout Muslims. When I first arrived I was not allowed to make any photographs of the women. Because I respected this, stayed long enough, and was friendly and open, I was welcomed into some of the tents, and spent most of my time visiting in a particular one. On my last day, the tent filled up with women who gathered around me and insisted that I make pictures of them.

In countries where there is a lot of tourism, you will find the people quite used to foreigners who want to photograph everything. In these places, you are generally free to photograph what you want to, even if it sometimes goes against local custom.

You may be asked to pay for photographing certain people. My advice is to comply with such requests. You pay for a postcard when you travel, why not for an image you make? It is usually not much money to you, but may be quite a lot to the person you want to photograph. If you do not want to pay, you can always move on.

Spending time with people and photographing them should always be a win-win situation. You and your subjects should enjoy the experience, and both of you should get something good out of it.

People in most traditional cultures want visitors to be happy, and you will find that they will go out of their way to help you do whatever you want to. Remember that you are an ambassador of your own culture and of photographers. Leave a good trail.

Tip

If you are traveling in a foreign land, learn at least a few phrases of the local language. Your reception and ability to make photographs—and your whole experience—will be enhanced.

CARY WOLINSKY
Seeking the Human Spirit

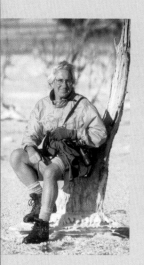

CARY WOLINSKY has always had a passion for story-telling. He began working as a news and magazine photographer for the *Boston Globe* while enrolled at Boston University's School of Communications, and by 1972 was providing free-lance photo stories to national magazines.

He became a contract photographer for NATIONAL GEOGRAPHIC in the mid-1980s, with assignments that have taken him to almost every corner of the globe. Like most Geographic photographers, Wolinsky is adept at all sorts of photography, but images of people occupy a special place in his heart and mind.

"People photography is completely different from anything else," he says. "When you make landscapes or other types of images, you are after something symbolically or graphically interesting. With people, you are after some-thing else, some glimpse into the human spirit. I know I have a successful image when there's a moment—the thrill of connection, one human being with another."

Whether he is shooting around his home near Boston, in India, Australia, China, or any

Photographer Cary Wolinsky (left) has travelled the world for NATIONAL GEOGRAPHIC to photograph stories on subjects like silk, color, and the history of writing, each of which take a great deal of imagination and

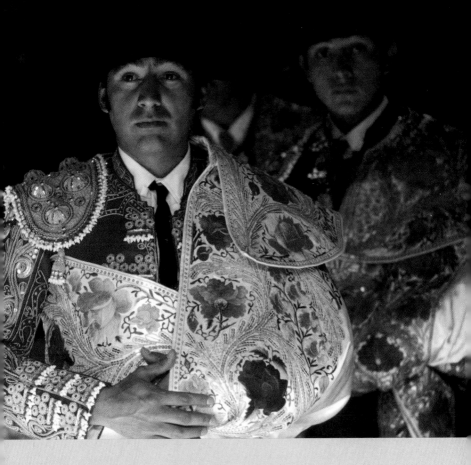

creativity. In the image above, soft light reflected from the ground adds drama to the portrait of a Mexican matador waiting to enter the ring on the occasion of his 500th bullfight.

of the other places he's worked, Wolinsky is after the same thing: "For pictures of people to work, they must evoke an emotional response in the viewer. You can have a beautiful image—graphically interesting, beautifully lit, perfectly composed—but if the human connection is missing, it will not resonate, it will be empty. People pictures should get at the universals of the human condition. Every person has a story. Our job is to evoke it visually.

"I like the human form. Watching it in all its drapes can be spellbinding, whether uncut cloth in India or high fashion on a runway in Milan. Looking through the viewfinder, observing how

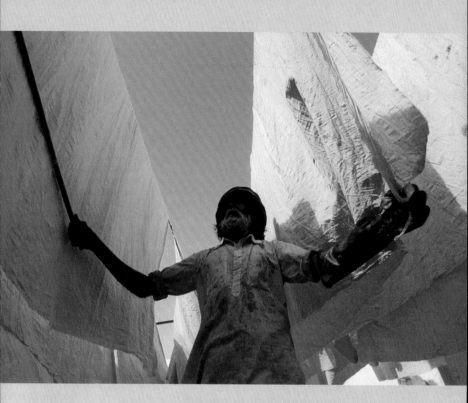

How to say "yellow": While illustrating a story about color, Wolinsky had to come up with imaginative ways to show colors and their uses. Using a low angle and a wide lens, he dramatically emphasized the yellow cloth being hung up to dry in India.

a person moves and how he or she relates to the scene is like a dance of which I am a part. And to me, the human face is the most powerful photographic element in the world. Even when I am photographing museum objects, if I have a choice of working with something that has a human face, I will choose that over other artifacts.

"Making pictures is an evolutionary process—the human face changes by the millisecond. Eyes carry an enormous amount of content, tell a great deal of the story, as does each little movement of the mouth or brow. You have to be totally engaged and connected to recognize the moment, and to seize it."

Wolinsky is renowned for the amount of research and preparation he puts into his assign-

ments, for thinking carefully about his subject and figuring what he can do to capture it meaningfully. He reads voraciously, makes extensive shooting lists, and stays focused on what he needs to tell the story.

"On any one day, there are billions of possibilities for pictures," he says. "You are inevitably going to miss most of them, but you want to get a few you are really happy with. The important thing is to prioritize. I first think about what kind of images I want: Tight head shots? Wide shots of a whole scene? Then I figure out the appropriate gear and pack my camera bag only with what is essential. You need to be comfortable and light on your feet—energetic and alert, not burdened down with equipment."

But careful planning and research shouldn't get in the way of being open to the complexity of evolving situations and to serendipity.

"When you are doing street or any kind of people photography, you have to be on your toes—you never know what the world will present. I spend a lot of time wandering around, and then something about a scene arrests my attention and makes me stop and think about what it was that touched me. It might be a person's face, an activity, a relationship—could be anything. I raise the camera to isolate that element, and then move around to make it more compatible with what is graphically interesting. I know I've got my subject, but photographs have to work graphically in order to provide a window through which the viewer can access the bit of the human story that lies within."

Wolinsky's advice to photographers is to study the work of others and to practice, practice, practice. "If you are thinking about your equipment while you're shooting, you don't know it well enough," he says.

And make time for photography. "To transcend average photography, you have to be totally focused. You have to concentrate completely on the act of making an image, which calls on all your technical abilities and life experience. And of course, it is easiest to be absorbed by things that make you happy. Figure out what you have the most fun photographing and go out and make images. The pleasure you have making them will be shared by the viewer."

Architectural elements frame this portrait of a Muslim woman. Think how different this image would feel without the little girl in the background, who seems to be contemplating her likely future as a woman.

Wolinsky's Photo Tips

■ Scout: Do a lot of walking around, looking for places that are interesting, where to photograph them from, and figuring out when the light will be good. Make notes on when to come back.

■ If you're shooting in a street and people become uncomfortable, be friendly and ask permission. If you want to make candids, work your way into some activity—a festival, parade—where people are busy and unlikely to mind being photographed. These are great situations in which to learn and practice.

■ Reserve some time for photography when you are traveling. Put it on your schedule and allow plenty of time. Making images should be purposeful, not incidental.

■ Don't wear sunglasses while you're shooting. Making meaningful pictures of people means making eye contact. Sunglasses make you look threatening and alien. They also don't allow you to see the real colors of the scene. Wear clothes that are appropriate to where you are.

■ If people want to be paid for allowing you to make pictures of them, and if that is part of the custom, don't buck it. They are providing you with something, and the relationship should be mutually beneficial. You might also think of carrying little gifts rather than money.

■ If you want to make candid pictures unobserved, find a blind. It might be inside a store looking out through the doorway, or anywhere you can get out of the way.

■ Carry a film extractor. If you are moving from outdoors to indoors you will probably want to change film types but may not have finished a roll. Rewind the film, write the frame number on the canister, and extract the leader so you can use the rest of the roll when you return outside.

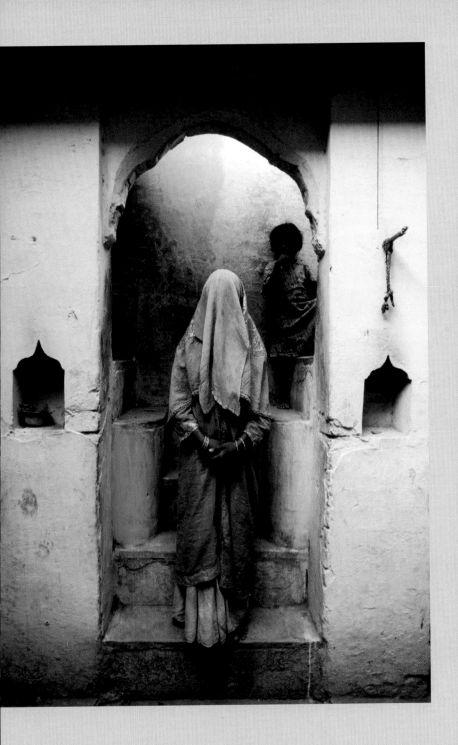

MOTION PLAYS AN IMPORTANT PART in conveying what many subjects are all about. The obvious ones are people engaged in sports, but the idea also applies to things as simple as a man walking down a street or a child coming down a slide.

There are three ways to show motion in photographs: freezing, blurring, and panning. Each one has its own feeling and is accomplished with a different technical manipulation. The best way to learn about them is to try them out. Stand on a street corner and freeze pedestrians and cars that pass. Blur them. Pan with them. Experiment with shutter speeds. Keep notes and compare results to see which works for which situations.

Freezing Action

Freezing someone in motion can be accomplished by using a fast shutter speed. How fast depends on what they are doing—a person walking can be frozen at 1/125 of a second, while someone smashing a tennis ball might require 1/1000. Think about what the action is, then determine the appropriate shutter speed.

Freezing *implies* motion rather than shows it. There is no actual movement in the photograph, but we understand when we see someone with one leg in front of the other and one foot off the ground that they are walking or running because people don't normally stand like that. We know that the diver is on his way to the pool

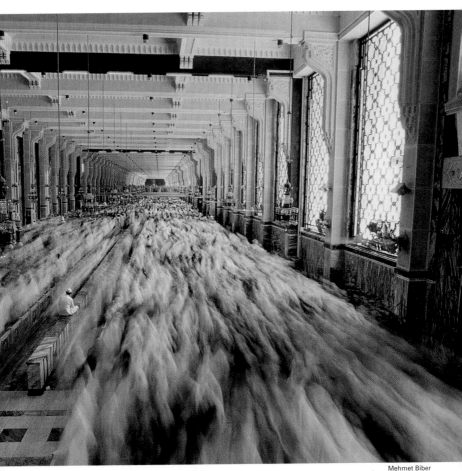

Mehmet Biber

because people don't normally hang in mid-air.

Think about what you are trying to say with your image. Since freezing does not actually show motion, it may not be appropriate for all situations. If you make an image of a race car going 150 mph and you freeze it at 1/2000 of a second, the photograph will look exactly the same as one made of the car standing still on the track. If you want actual movement in the image, either the subject or the camera has to appear to move. Use a different motion

By including one still figure, using a slow shutter speed, and keeping the camera steady, the photographer created a dramatic image of motion. Notice the photograph is framed with the seated man off-center.

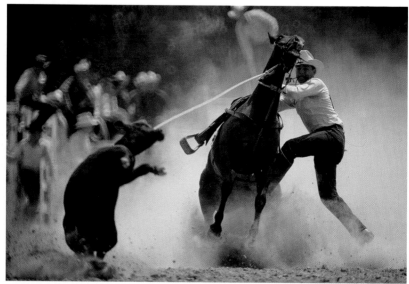

Bruce Dale

Frozen with a fast shutter speed, a cowboy, his horse, and a roped cow are caught in mid-air. Dust kicked up by the action makes a perfect backdrop, making all three stand out. In such images, we understand the movement from the subjects' unusual positions.

technique or look for some other element that will give a sense of speed—splashing water or a trail of dust, for example.

Since freezing usually requires a fast shutter speed, you will have little depth of field to work with. Focus carefully. And learn to anticipate. If your subject is moving fast, you have to figure out where it will be when you press the button. A fast subject could be out of the frame by the time the film is exposed, so give it some room in the direction it is moving. Always be aware of your composition and where your subject will be in the frame. If you are using an SLR camera, you will not actually see the instant that is recorded because the mirror pops up to get out of the way of the light reaching the film.

Blurring

Blurring can be accomplished in two ways. The camera is held steady, a slow shutter speed is used, and the subject moves at a speed that is too

fast for that shutter speed to freeze; or you can use a slow shutter speed and intentionally move the camera, blurring everything.

In the first case, if only the subject is moving and everything else in the frame is stationary—a sprinter running past a wall, for example—only the subject will blur, and it will stand out against the still background. A motorcar speeding past a crowd can be shot so that the shutter speed blurs the car but not the crowd in the background. How much blur you get depends on how slow the shutter speed is and how fast the subject is moving. Too much blur can cause the subject to be unrecognizable. That can work, too.

You can also make the subject stand out by doing just the opposite. Ask a friend to stand still on a street corner. Shoot her with a slow shutter speed so that everyone rushing past her blurs and she stands out in contrast. You may need a tripod or other camera support to shoot below 1/30 of a second.

By using a slow shutter speed, the photographer allowed the movement of the dancers and their twirling lights to create a swirl of color. Try several different shutter speeds in situations like this to be sure of getting one that works.

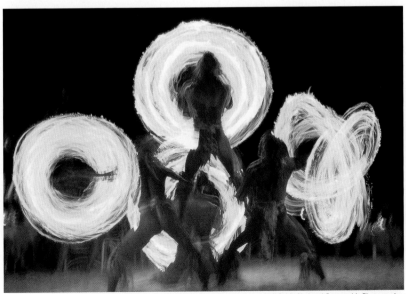

Jodi Cobb, National Geographic Photographer

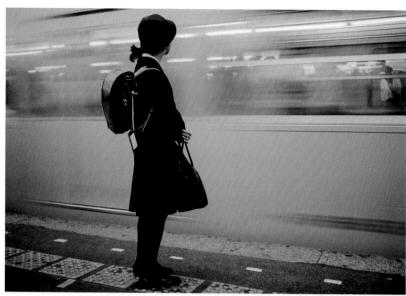

David Alan Harvey

Noticing this girl as she waited for the train to arrive, the photographer used a slow shutter speed to let the train blur while keeping her perfectly sharp. When both the subject and the background are moving, as in this kayaking image, a slow shutter speed produces an impressionistic effect. Different shutter speeds produce different amounts of blur. Try several.

Chris Johns, National Geographic Photographer

If you intentionally move the camera while the shutter is open, everything in the frame will be blurred. How much it's blurred depends on how slow the shutter speed is and how much you move. You can move the camera in all sorts of ways—left, right, up, down, in, out, or swirl it in a spiral. Each of these motions will achieve a different effect, and the only way to see how is to practice.

Panning

Panning means moving the camera with the subject so that he stays in the same position in the frame while he is moving. How fast you have to pan depends on how fast your subject is moving, at what angle to you, and how far away he is from you. Panning a walking person is fairly easy. Panning a race car takes practice.

The result of a panned shot is a sharp subject and a blurred background, giving a sense of motion and speed. If the background is only a little blurred, we perceive the subject's speed as fairly slow. If it's very blurred, we see it as fast. The shutter speed and the panning speed will determine the amount of background blur.

The first thing to do if you're planning to pan is to determine where you are going to actually make the picture. Look along the path the moving subject will take and find the frame you want it to be in. Then stand with your feet pointing at that spot as if you were going to make an image. Focus and set the exposure with a shutter speed that will give you the motion you want, then twist your body back along the path the subject will take, leaving your feet pointing toward the final spot. It's easier and more fluid for your body to return to a comfortable position than to go from a comfortable to an uncomfortable one.

When the subject enters the viewfinder, start panning along with him, trying to keep him in the same position in the frame. Press the shutter button as you get to your predetermined spot, but don't stop panning. If you are shooting with an SLR camera, you won't be able to see the subject at the actual moment of exposure, but don't let that stop your motion either. To get a rendering of fluid motion, stay with the pan until you can see the subject again.

Tip

Practice in your neighborhood. Go out on the street and make frozen, blurred, and panned images of passing cars.

Panning with the subject keeps it sharp while blurring the background, thus giving a

Robert Caputo

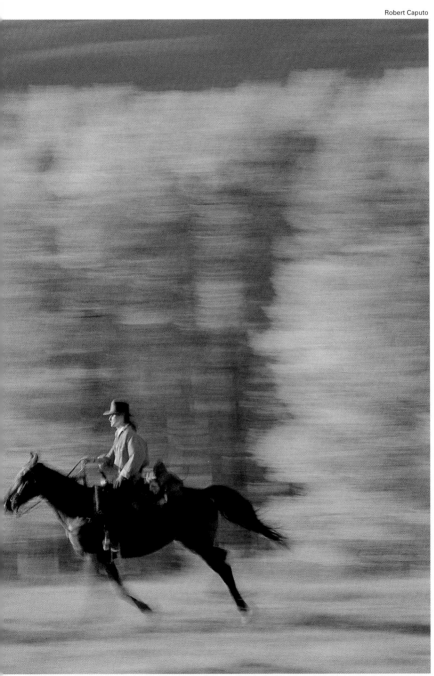

sense of the subject's speed. A telephoto adds to the blur of trees in the background.

Blurring, Panning, and Freezing With an Electronic Flash

A very effective way of showing motion in photographs is to blur or pan a subject and then freeze it with the light from an electronic flash. It's sort of like having your cake and eating it too. In these kinds of shots the subject can be rendered with both the detail of a frozen shot and the motion of a blurred one.

The technique is to set your electronic flash on rear curtain synch so that it fires just before the shutter closes rather than just after it opens. This will give you a trail of blur ending at the frozen subject, which is generally more dynamic than if the electronic flash fires at the beginning. Use a shutter speed of 1/30 or slower, depending on the kind of action, how much ambient light there is, and how much of a blur trail you want.

To let the subject blur/freeze, hold the camera steady (you may have to use a tripod), press the shutter release, and let the action happen until it is frozen at the end of the exposure. If you want to blur by moving the camera, think about the

Straight flash and motion with flash: The image at left was shot at a fast shutter speed, freezing the woman as she emerged from the car. By slowing down the shutter speed and popping the flash unit at the end of the exposure, the photographer captured a sense of movement and quite a different feeling.

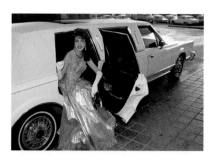
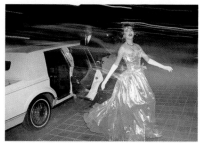

David Alan Harvey (both)

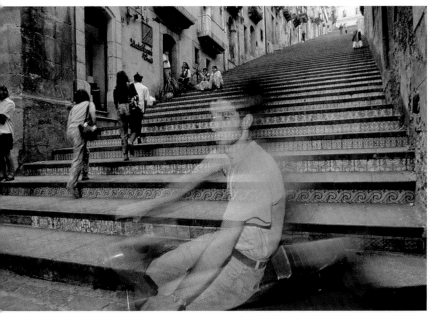

William Albert Allard, National Geographic Photographer

kind of motion you want the photograph to show. While the shutter is open, you can tilt the camera up or down, left or right, even swirl it around. Press the button, then move the camera as you've decided until the flash goes off and the shutter closes. For pan/freeze, press the button and pan with the subject until the flash fires.

In all these cases, opening the processed film is like opening a surprise package—you never know exactly what you'll get. Because of the time lapse between pressing the button and the firing of the electronic flash, you can't know where the subject will be at that moment. If you're working with an SLR, you can't see anything through the viewfinder during the length of the exposure.

Experiment a lot with this technique. Try it with a range of shutter speeds, in both strong and low light, always taking into consideration the existing ambient light and how you want to render it. Keep notes to see what works.

Don't use electronic flash units only when it's dark. A setting of 1/60 of a second was enough to freeze the women climbing the stairs in this image. Combined with a flash, the photographer created a "ghost" of the guy on the scooter whizzing past. Use your imagination when showing movement.

LIKE ANY OTHER TYPE OF PHOTOGRAPH, portraits should be both *of* and *about* your subject. They should capture the personality and spirit of the person as well as the physical features. You're not making an image of a mannequin—the photograph should be alive with the person's character.

When we look at a good portrait, whether a painting or a photograph, we get a sense of who the individual is. In head-shot portraits, this is accomplished almost entirely with facial expression, with lighting and background contributing to the mood you are trying to convey. With wider portraits—full-length formal or environmental— everything else in the frame needs to reinforce the basic message you are communicating about the subject's personality. Look carefully through the viewfinder to make sure there is nothing that strikes a discordant note.

The first and most important thing is to get to know your subject. If he or she is someone you know, then you have already accomplished this and you need only to think about which aspect of personality you wish to convey. If the person you are photographing is a stranger, spend a little time chatting before you start making images. If you are working in a studio, allow time for coffee or a snack before the photo session. Show them other portraits you have made, tell jokes to find out about their sense of humor, talk about the news, ask them

Softly and evenly lit, and with great depth of field, this full-face portrait gives us a sense of the woman with no distractions. Pulling back her hair so that it, too, is out of the way, adds to the effect. When making portraits, think about what you want to say about the person and use light and composition to help you say it.

Jodi Cobb, National Geographic Photographer

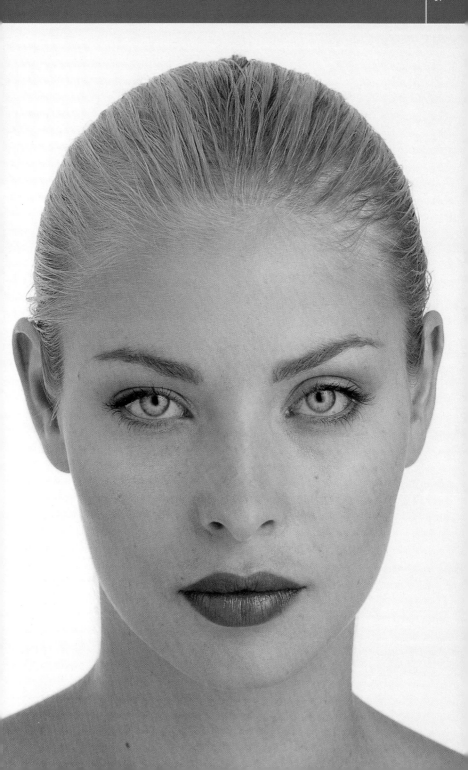

about their hobbies, tell them about yours—anything to break the ice. You're trying to get a glimpse of their personality so you know what to go for, and the only way to do it is to engage them. They have to trust you before they will open up enough to allow a truly revealing portrait to be made.

If you are out in the street, you may want to shoot portraits of people you happen to see. Something draws you to them, singles them out

Two images of the same bride feel very different. Think about the person and the situation you are photographing, and decide what to include in the frame and what to cut. Everything in the image should have a reason for being there.

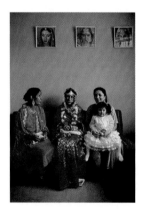

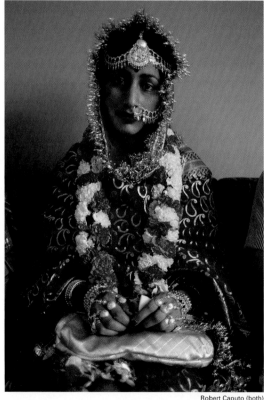

Robert Caputo (both)

from the crowd, and makes you choose them as a subject. What is it? Their eyes? Their smile? Their weathered face? Decide what attracts you, how it reflects their personality, and how you can capture it. Then decide if this is best accomplished by being unobtrusive or engaged.

Whether you're making formal or informal portraits, looking at, listening to, and thinking about your subjects will help you figure out how to shoot them. A head shot of Albert Einstein makes sense. One of Arnold Schwarzenegger probably doesn't.

Study books of portraits, both paintings and photographs. Think about how the artists accomplished their goal of communicating a person's character. Notice the mood, how the person is posed, how the light falls, the other elements included in the frame. Apply these techniques to your own work. We can all learn from the efforts of others.

And practice. Make formal and informal portraits of members of your family. Make head shots, full-length formal portraits, informal ones in all sorts of situations, environmental ones. Then make some more.

> **Tip**
>
> If you make a lot of portraits, try specially made color negative "portrait film" designed to render flesh tones accurately.

Formal Portraits

Head Shots

Head shots are straightforward blasts of personality. You have no other elements in the frame to distract the viewer from the person's face. It is the most intimate kind of photography. You need to establish a rapport with the subjects that allows them to let down their guard, open up, and reveal themselves.

The eyes really are the windows to the soul. When we meet people, the first things we look at are their eyes. The same is true of looking at a

portrait. The expression in a person's eyes—of mirth, seriousness, sadness—sets the tone of the image, so pay careful attention to capturing it. The eyes should also be in sharp focus, even if other parts of the face are not. If you are shooting with little depth of field, be sure to focus on the eyes. The one closest to the camera is the most important.

As we mentioned in the beginning of this chapter, take time to get to know your subject. Once you have decided what aspect of their personality you want to capture, think about how this would best be achieved. One thing to consider is the relationship of the subject's face to the camera.

Some people might best be photographed facing straight into the camera, their eyes staring at the viewer. This is the most direct sort of portrait, and the one that demands the most of the subject. It is not easy to relate to—much less project your personality through—a piece of glass. When we view portraits like this, we feel a direct connection with the subject.

A 3/4 portrait, when the subject's head is pivoted away from the camera, is less direct. The subject is usually gazing off somewhere, and because of convention we read emotions into this kind of portrait. If they are gazing up, we assume they are thinking lofty things. Looking down connotes pensiveness.

Profiles are portraits with a strong graphic quality. We are not directly engaged with the subject and are interested both in the character of the face and in the line created by the profile.

There are many variations of these three basic poses. You can have someone facing the camera but looking up, down, or off in the distance. You can shoot a three-quarter view of someone but have them look at the camera. A profile can be

Tip

Use face powder to reduce hot spots on the skin.

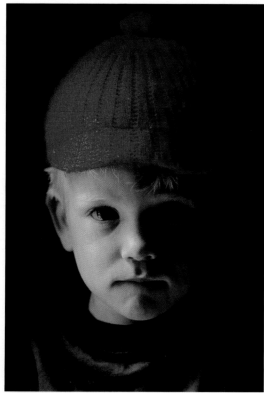

William Albert Allard, National Geographic Photographer

Dramatic side light enhances this portrait of a little boy, but his expression and his red hat keep it from being somber. Because the photographer and his subject were engaged with each other, we are rewarded with the boy's open gaze.

shot with the subject's eyes closed. In any of these, the head can be tilted to one side or resting with a hand under the chin or on a cheek.

If you want your subjects to smile or laugh, tell them jokes while you are shooting. If you want them to be pensive, ask them to tell you about something that has made them so. You need to keep relating to them while you are shooting. One way to do this is to mount the camera on a tripod, compose the image, and move from behind the camera so the person can see you. With a remote shutter release you can shoot without looking through the camera.

Think carefully about the background for your portraits. In most cases you want it to be

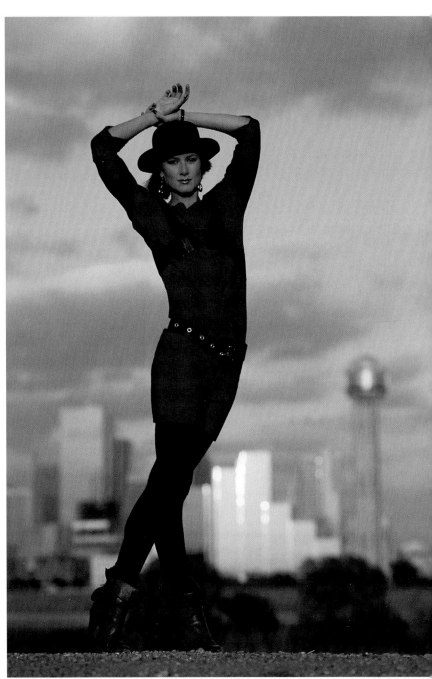

David Alan Harvey

simple, usually one color. It should not distract from the person. The color you choose will say something about the person—a red background would feel very different from a gray one. And choose the right shade of color; you don't want the subject's head to melt into the background.

Full-Length

All the things we discussed about head shots apply to full-length portraits, except that you have much more to work with and be concerned about. You are not relying solely on the person's face—their body, body language, clothes, and the background all play their parts.

You need to get your subjects to cooperate, feel relaxed, and reveal themselves. Everybody gets self-conscious in front of a camera, and this is even more true for full-length portraits than for head shots because people feel awkward—they don't know how to stand or what to do with their hands. You need to help them get over it.

Engage your subject in conversation before and during the shoot, and don't be shy about directing him or her to stand this way or that. You are supposed to be the expert, and your subject will look to you for advice and direction.

Many people show up for a portrait session dressed in their Sunday best. If you want a more informal session, start shooting them dressed as they came. They obviously put some thought into this, and you don't want to make them feel as if they made a mistake. Then suggest that they loosen their tie or remove their coat.

Think about how the subject should pose, what he should do with his hands, and what that will say about him. A tough football coach might face straight into the camera, hands on hips. A cheerleader might jump into the air. A psychiatrist might sit, hands folded in lap.

Settings are important in full-length portraits. If you are shooting against a drop or other studio background, think about the color and how it effects the mood of the image. If you are outside, as in the picture at left, think about placement and depth of field. By including the tower in soft focus to the right of the model, the photographer made the composition more dynamic and reinforced the verticality of the frame.

Robert Caputo (both)

Using the right lens is especially important for head-and-shoulders shots. Wide-angles distort facial features and force you to crowd the subject, as in the image at left, made with a 24mm lens. The image at right was made with a more flattering 105mm. Short telephoto lenses are kinder to your subject and allow you to stand back. Wide-angles are useful for certain subjects, such as clowns.

Choosing the Right Camera and Lens

Most professional portrait photographers use medium-format cameras. The larger negatives and transparencies capture finer detail than 35mm film and produce smoother tonalities. In the field, carrying the larger format equipment has its drawbacks. But you can also make very good portraits with 35mm gear. Remember, it's the singer, not the song. The gear you have is less important than what you do with it.

Whatever format you choose, you will usually want to use a short telephoto lens to make head or head-and-shoulders portraits. Wide-angle lenses distort features and would make a person's face round if you were near enough for the face

to fill the frame. You would also be crowding them and probably making them feel uncomfortable. In 35mm format, a lens between 75mm and 135mm is best. It flatters the person's features and allows you to back up.

But remember that telephoto lenses have little depth of field. Do you want every part of the face from the tip of the nose to the ears to be in sharp focus, or only the eyes? Decide beforehand and set the camera accordingly. Unless you want blur, don't go to a shutter speed below 1/60 of a second. If you want a lot of depth of field, you may have to add light or use faster film.

Engage the person while you are shooting so you can capture several different expressions.

The image at lower left was made with a key light only, creating dramatic side light. If you don't have a reflector or second electronic flash, turn your subject's face toward the light to get an image like the one below, right.

Robert Caputo (both)

Motor drives are quite useful for this. People often tense up just as you are about to shoot, and then relax just afterward. With a motor drive you can get that moment, too.

For full-length portraits, choose a lens that can include the whole person but is not so wide that you get distortion—unless you want it. It's probably best not to use a lens so long that you have to be far from the subject, leaving her standing alone without anyone to engage with.

In setting up for the portrait shoot, know where you want the person to pose. Choose your background and/or surroundings. If you're working indoors, get your lights and reflectors up and tested before the person arrives. If you're working outdoors, scout the location and set up lights if you need to. You don't want your subjects to have to stand around getting nervous while you are busy with technical things. You want to devote all your attention and energy to them.

Angles

Judges sit on raised platforms so we will have to look up at them. They, in turn, look down on us. The conventions of angles are as follows: Looking up at someone endows them with power, authority, heroism. Looking down on someone implies their weakness or cowardice. The more extreme the angle, the greater the emphasis on the connotation. Painters, photographers, and movie directors have long used these conventions to reinforce our feelings about the characters they portray.

What angle would be most appropriate for your subjects and what you want to say about them? If you're shooting a basketball player, you may want to emphasize his height. If you are shooting children, you may want to get down to their level.

Tip

If you will be using an electronic flash as your main light, aim a flashlight at your subject from the same position to see how the shadows will fall.

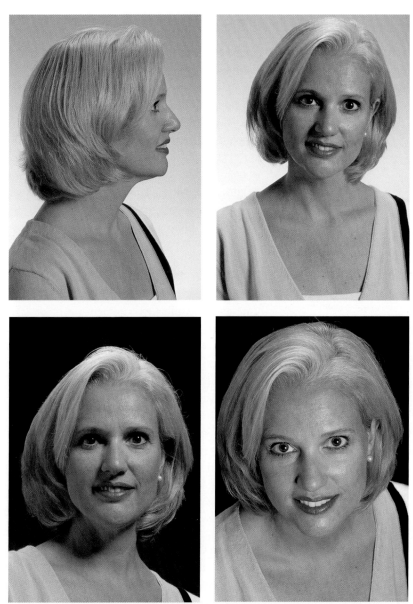

Robert Caputo (all)

These four images show the effects of different camera angles on the woman's face. We get different feelings about the woman when she is photographed in profile, full-front, from below, and from above. Notice also how the light and dark backgrounds affect our impression of the subject.

Robert Caputo

Most people, like the girl above, are happy to have their picture made if you are quick about it. If you take too long, they will get self-conscious and the moment will be gone. The image at right achieves a perfect balance: enough of the environment to complete the story-telling aspect of the image, but not so much that the impact of the person is lost.

Informal Portraits

Informal portraits can be made in a studio, on location, or in the street. They can be simply more casual, as the name implies, or they can be dramatic, humorous, or satirical. One type is essentially candid, either of strangers (see Candids with Consent in Street Photography); of family members at home, at the beach, on a picnic; or of clients. The other type requires more thought, imagination, and preparation.

The Casual Portrait

Wherever you are with your camera, always be on the lookout for those moments when a person's character shines through. If you have a formal portrait session with someone, make some frames of him while he straightens his tie or while she brushes her hair before the formal sitting. Walk back to the car with her and shoot her on the street. If you are on a spring picnic with the family, look for that moment of bliss when your wife leans back, sated, to enjoy the caress of the warm sun. If you're on the street, look for the impatient expression on a pedestrian's face as he waits for the light to change. Always be on the lookout for the telling moment. Every person has a story, and every picture should tell part of that story.

Be prepared. If you're on the street looking for portraits of passersby, have an 80-200mm zoom on the camera so you can compose quickly. In your house, keep your camera easily accessible. And practice. Whether you are shooting portraits in a studio or out in the world, the only way to get good at both the technical aspects and the thoughtful aspects is to make a lot of pictures. We all make mistakes—lots of them. It's how we learn.

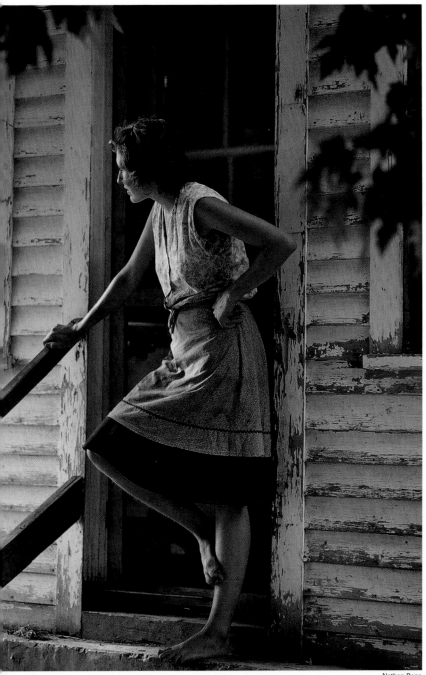

Nathan Benn

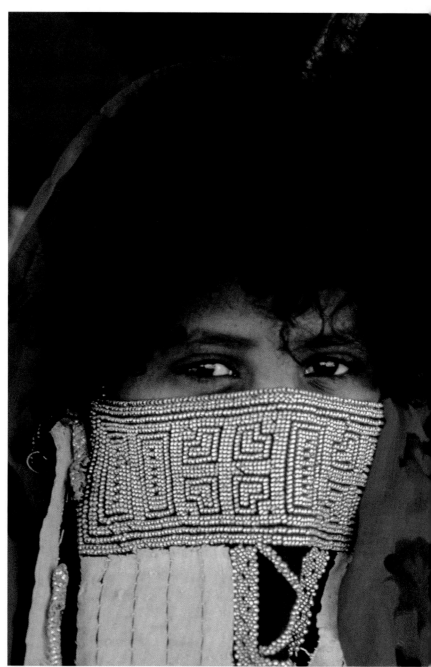

Fill the frame: By respecting customs and earning the trust of these shy women,

Robert Caputo

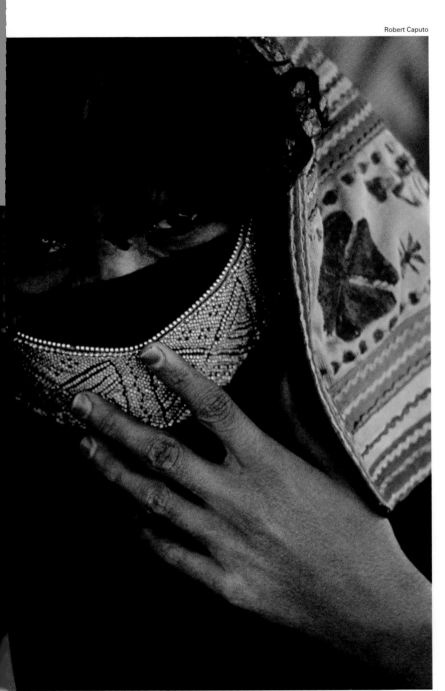

I was allowed to photograph them and record their direct and intimate gazes.

Cary Wolinsky

What does your subject do for a living or for a hobby? Think of how to show that activity in an imaginative way. This image of a stunt flier upside down is much more interesting than one of him right side up or standing by his plane would have been. Look for things in a subject's home or office that will help you tell the story, as in the montage at right.

Cary Wolinsky

Portraits With a Twist

Another sort of informal portrait involves some of the same skills as directing a play or movie. In these, you either use a location as you would a stage or perhaps even construct one for the photo session. The idea is to go beyond the obvious, to shoot the person in a way and a setting that captures their personality through some funny, dramatic, or weird use of environment.

Bruce Dale

For example, you might shoot an archaeologist lying in a tomb, or a bird-watcher perched in a tree, or a diver in full scuba gear standing in your studio.

Use your imagination. Talk over ideas with your subject to come up with something really unusual. This is a collaborative form of picture making, and you and your subject should have a lot of fun with it.

Many magazines regularly feature portraits of this sort, so have a look at lots of them at a newsstand or in a library. There are also a number of books by photographers who work in this genre. Music CD covers are an especially good place to see how this sort of thing is done.

Use your imagination. To photograph a scientist who studies gravity and quantum physics, the photographer chose to make a conceptual portrait. By moving the camera through an arc and firing his electronic flash five times, he was able to create this dynamic portrait.

SISSE BRIMBERG
The Story Behind the Story

WHEN SISSE BRIMBERG was a teenager, she had a boyfriend. That's not unusual for a Danish teenage girl, of course, but her boyfriend's mother had an unusual occupation for a woman at that time. She was the first female press photographer in Denmark. Sisse and Inga Aistrup became fast friends, and the young girl tagged along on her various assignments, becoming increasingly fascinated with the whole process of photography.

"I admired what she was doing, all the different skills she had," Sisse says. "And I liked the fact that she was her own boss."

Brimberg had not been doing particularly well in school—no subject had really caught hold of her. But now her imagination was fired, and she was drawn into the world being opened up by her photographer friend. One day, they talked about what Sisse might do with her life.

"You are going to be a photographer, of course," said the woman.

"How do you know that?" Brimberg asked. "Do you think I have any talent?"

"Well, that remains to be seen—you haven't tried yet. And, by the way, it's easy."

"That was probably the best thing anyone has ever said to me," Brimberg says now. "Of course

Sisse Brimberg (left) has worked at NATIONAL GEOGRAPHIC since 1976, most often on complicated historical and cultural stories. "The more challenging the subject is," she says, "the more I love it."

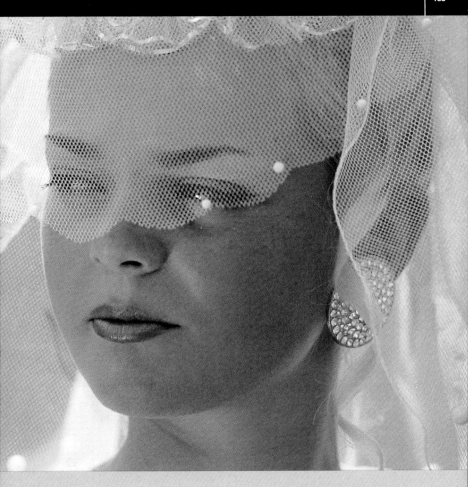

A bride in the Ukraine waits in the sun for the beginning of her new life. By using an 80-200mm zoom lens, Brimberg was able to get this intimate portrait without disturbing the woman's reverie.

it isn't easy, but by saying that at that time, she made photography seem unintimidating. She made making pictures seem accessible to me. I immediately asked my Mom and Dad if I could have a camera. They bought one for me and the next week I started making photographs. I've been doing it ever since.

"That magic I first felt with Inga has never left. Even today when I am working in a darkroom and I see the image appear miraculously out of the soup, I still feel the same tingle."

After finishing school, Brimberg got an apprenticeship with a commercial photographer and spent four years learning the intricacies of

studio lighting, at which she is today a master. She opened her own studio and was doing quite well, but felt something was missing. She found out what it was when she hooked up with a book publisher who began to send her on assignments around Europe and North America.

"On those trips, I discovered how much I liked making photographs of people out in the world. They took me back to those days I had spent with Inga Aistrup, of looking for real emotions and relationships. I loved it, and decided that that was what I wanted to do."

Brimberg set her sights on NATIONAL GEOGRAPHIC. "I hounded Mr. Gilka, who was then the director of photography," she says. "But of course, I realized that you have to crawl before you can walk. So I kept at my other assignments." A year later she became an intern in the photographic department.

Since 1976, Brimberg has covered all sorts of subjects and traveled the world for NATIONAL GEOGRAPHIC. Her particular passion is for historical/cultural stories that require a great deal of research and even more imagination. You can't photograph history, of course, so you have to find ways to make the past visible.

"Doing these stories is incredibly challenging, which I love. It's like doing a jigsaw puzzle. You do the research, all the time hunting for pieces you can use to construct an image of the past. You need to find things in present-day life that give the feeling of looking into history. Not just the artifacts, but the faces and the things that people still do that relate to where their culture came from.

"Photography is a process of discovery," Brimberg says. "Whenever I get a new assignment, I'm scared stiff, full of doubt. The subject seems like a vast, undiscovered ocean and my lit-

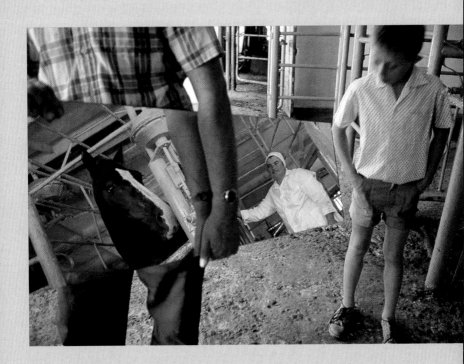

tle boat seems woefully inadequate. But I do the research, then get out there. I start making photographs on a daily basis, exploring the subject.

"At first it's like doing warm-up exercises, then those take you in a certain direction. You meet people, start discussing things with them. Often what you thought you were looking for in a situation isn't there, but those people turn out to have the key to the right door, and then you're away. It's very important to talk with people when you're out shooting, and to listen carefully. They know much more about the subject than you do, even if they aren't aware of it."

Brimberg sees her job as telling stories about people or subjects in a way that allows the viewer not just to see them, but to feel them too. Often this has led her into situations of great suffering and pain.

"My job shows me a lot of things it would be

The shoot in the stalls of a horse farm was over and the man at left was removing a mirror Brimberg had used as a reflector. As he passed by, she saw this image, which was better than what she'd had in mind. "Don't quit until you are back in your hotel room," she says.

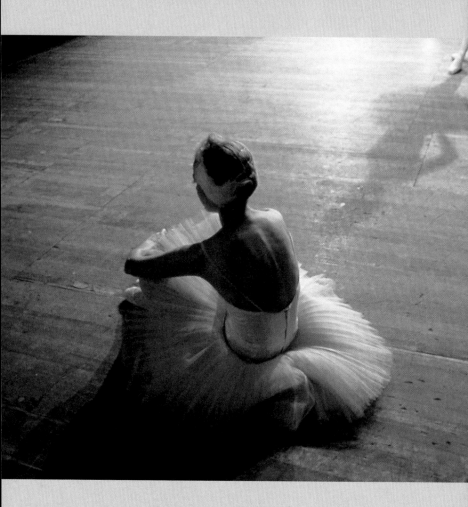

much easier to pretend don't exist," she says. "But our job is to tell those stories too—often to get into the private settings of peoples' lives, even when those people are in anguish. I think you become a more understanding and compassionate human being because you have been exposed to that part of life."

Like most other Geographic photographers, Brimberg believes that you need to be light on your feet and devote all your energy to image-making rather than to gear.

"I try not to look like a photographer when

By arriving well before a performance of Swan Lake at the Mariinsky Ballet in St. Petersburg, Russia, Brimberg was able to capture this moment of a ballerina waiting to go on stage. Get to places early and stay late.

I'm shooting," she says. "The less gear I carry around, the less people pay attention to me, and the more I can concentrate on making pictures. The less there is to grab for and fumble around with, the easier your job is. And sometimes you have to act really fast."

Brimberg's advice is to think hard about who your subjects are and how you can use what they do to shed light on that. "Try to understand what emotions are inherent in the story you are telling, and find ways to make them visual," she says. "Something draws you to your subject, makes you pick them out of a crowd. Make photographs of whatever that quality is."

Brimberg's Photo Tips

- Never wear clothing that makes you stand out in the crowd. You want to melt into the situation and be a part of it.

- Always carry a notebook. You need to make notes of the names of subjects and contacts, write down ideas you have, locations you have noticed that might be good for later shoots.

- When you scout locations, always take your camera—some things you will only see once.

- Always carry sunscreen with you. Photographers often have to wait and wait in the hot sun. You don't want to miss a picture because you were hiding in the shade.

- Spend time going through all your photographs after you've been out on a shoot. Look especially at the ones that didn't work and figure out why.

- Try new things with your camera. Doing things the same old way is scary. You owe it to yourself to stretch, to find your own voice. Sometimes you lose, but when you win, it's like no other feeling in the world.

PORTRAITS ARE ABOUT PEOPLE. Environmental portraits are about people and what they do with their lives. They are about the kind of house a person lives in and how they decorate it; about what kind of work they do and where they do it; about the surroundings they choose and the things they surround themselves with. Environmental portraits seek to convey an idea about a person by combining portraiture with a sense of place.

Conveying Your Subject's Vocation or Avocation

The first thing to do, of course, is to think about your subject and what part of his or her life you want to show: work, home, hobby, play, et cetera. Which of these aspects seems most important to your subject? About which do they feel the most passionate and proud? The only way to find out is to spend time with them.

In some cases, the choice of location will seem pretty obvious: an artist in her studio, a butcher in his shop, a teacher in class. But try to think beyond the obvious. Many people have another part of their lives that they care passionately about. Use your imagination—and theirs—to come up with something that works.

If you decide that you want to photograph someone in their house, ask them to show you around. Pay careful attention to them as they

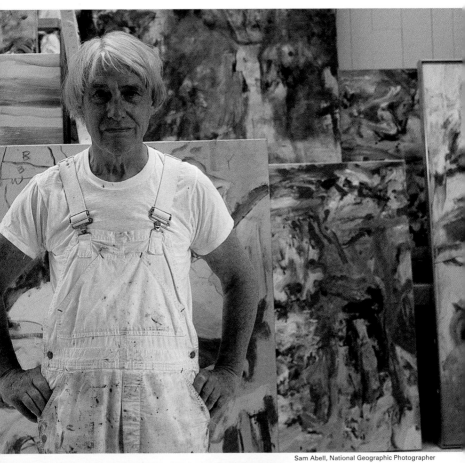

Sam Abell, National Geographic Photographer

William Albert Allard, National Geographic Photographer

The artist and the art collector. The portrait of Willem de Kooning above feels informal and friendly because of the artist's expression, his work clothes, and the studio setting. The picture at left is more formal, as befits the woman, the art, and the room.

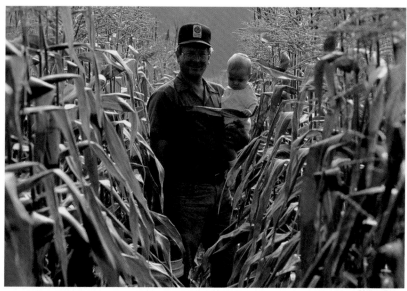

Melissa Farlow

A farmer's pride in his crop and his child comes through in this image. When making environmental portraits, take the time to find out what your subjects really care about and have them show it to you.

do—people will usually stay longer and talk more in the room or the part of the garden they like best. Ask a farmer to show you around his place, a model railroad enthusiast to show you his layout in the basement. Then ask your subject if you can stay while he gets on with his work or hobby. Don't make pictures, don't even take your camera. Just take it all in.

Watch your subjects carefully, noticing how they move around the room or other area where they are working, and what tasks seem to particularly engross them. Keep your eyes open. Make mental notes of the kind of clothes they wear, the tools they use, all the telling little details that are part of that aspect of their lives. Hanging out with your subjects gives you the opportunity to observe them, to figure out not only what environment to photograph them in, but what other things to include in the frame. And it gives them a chance to get used to you being in the room.

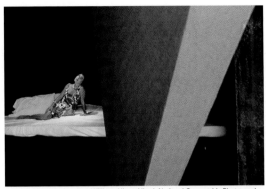

The strong, thrusting line contrasts with the soft bed and woman's languid pose to create a dramatically tense composition in this image. Use elements you find on the location to enhance your image and make it more interesting.

William Albert Allard, National Geographic Photographer

Scouting Locations

If you are going to photograph the person in a space they normally frequent, you can scout the location as you're first getting to know them. If you want to shoot them in another location, visit it beforehand on your own. In either case, look at both the physical characteristics of the space and the light. Think about how much of the place you want to include in the frame. Where is the best position for the subject? If it is an indoor space, you may have to light it with electronic flash and/or reflectors.

Ask the subject if you can visit the space sometime when no one is working there, and take your camera along so you can look at it through different lenses. If you do need to light it, set up a time when no one is there. Remember that you and the subject may be moving around within the space, so set up the lights so they are not in your way.

If it is an outdoor space, visit it at different times of day to see how the light falls and to determine what time of day would be best for the shoot. Think about whether you will need electronic flash or reflectors. If so, give yourself time before the shoot to set them up.

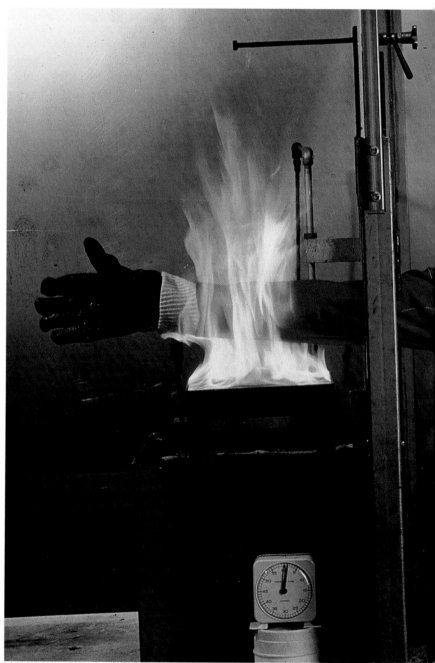

What better way to show the qualities of a flame-resistant material? The man's

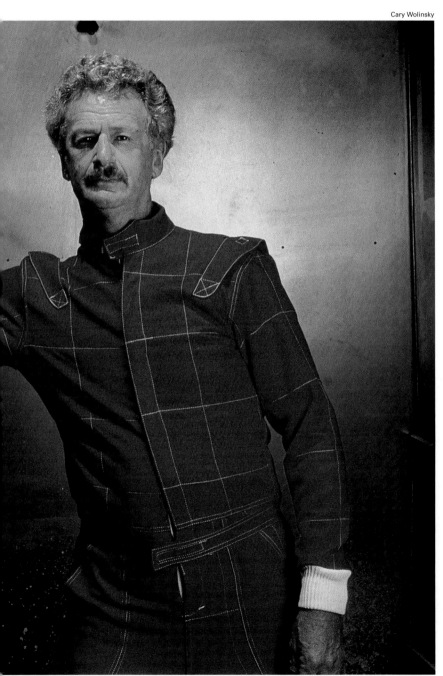

calm, straightforward look adds a touch of humor and helps convince us, too.

The Shoot

Even if you've spent a bit of time with your subjects, they will probably be a bit nervous and self-conscious when you first show up to actually make pictures. That's normal. Don't push them. Just hang around. At some point, they'll become engrossed in their work or other activity and forget about you. Then you can start working.

Don't forget that this is an image both of the person and of his surroundings. You want the person to be large enough in the frame so the viewer can see him, but you also want to include enough of his surroundings to get across the information and the feeling you are after. Use the different techniques of composition we discussed earlier to accomplish this.

For example: If you are photographing a baker, you might want to shoot him with rows of fresh bread in the foreground leading to him. Or you might want to have him large in the foreground with the bread stretching behind. Make pictures while he is carrying sacks of flour, kneading the dough, pulling loaves out of the oven. Think of an environmental portrait in much the same way as you would think of a photographic essay. You want to capture the essence of the person and what they are doing.

Be patient. If you're in a hurry, you will make the subject nervous. When he becomes engrossed in work or play, look for that expression of concentration. You may have to wait for telling details to appear: the sweat on the weightlifter's brow, dirt under the gardener's fingernails. Move around your subject, trying different angles. Move closer. Move farther away. Every once in a while, ask your subject to look up at you. Make a lot of frames, always watching for the moment that helps tell the person's story.

Tip

When you first arrive at a new location, make note of any features that strike you. Try to find ways to incorporate them into your composition.

Two photographs of a man at the same location communicate different kinds of information and feelings. In the image above, we sense a connection between the man and the ruins, but are unsure just what it is. In the image below, we can make a clear connection between the man and his parents' homestead.

Bruce Dale (both)

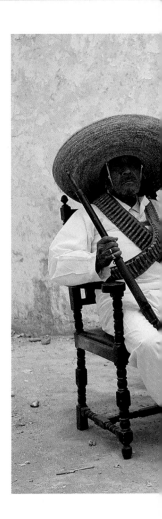

GROUP PORTRAITS ARE HARD TO DO WELL, and the larger the group, the harder they are. It's not easy to get a good, telling photograph of one person, and the problems are compounded exponentially with groups. We have all had the experience of trying to get the family or the ball team to pose for a picture. Just getting all of them arranged so you can see their faces is hard enough. Then, of course, you want an image where everyone looks good—no one's eyes closed, no grimacing. Making group portraits takes imagination, patience, and diplomacy.

First, think about what kind of group this is. Is it a family reunion, a convention, a Little League ball team, a dance troupe? There are basically two kinds of group portraits, and you want to decide which kind to make.

The first and most common sort of group portrait is simply a photograph of everyone who is present. These are very straightforward images in which the goal is to be able to see everybody clearly. In these, you have two major concerns—positioning and light.

If the group you are shooting is small, positioning is not a big problem. If it is a big group, however, you will need to stack the people in some way so that everyone is visible to the camera. If you are shooting indoors, use a stairway or a landing, or simply have the people in front sit or kneel. If you are outdoors, use whatever is available—bleachers, sand dunes, a hill. And be

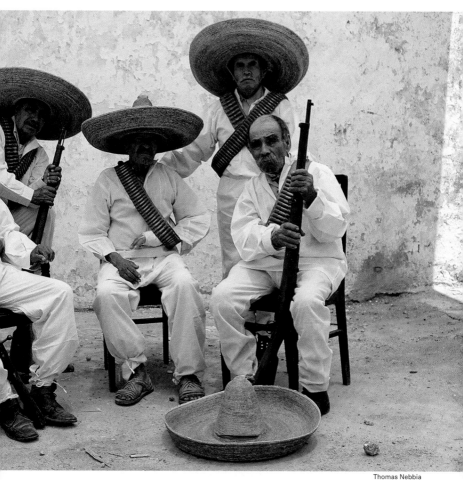

Thomas Nebbia

aware of light. You want to avoid some of the people casting shadows on others, so position the lights to avoid this. Outdoors, the diffuse light of overcast days is perfect for group portraits because of the lack of shadows.

You can also raise the camera position to get a better view of everyone in the scene. Stand on a chair next to the dining table, climb the stairs, a tree, or anything else that is available and have the people gather below. Many photographers who regularly photograph groups carry a ladder.

The last living members of Zapata's army pose for a group shot. Their old weapons tell us of their bravery as young men. The fact that they are seated implies that their fighting days are past.

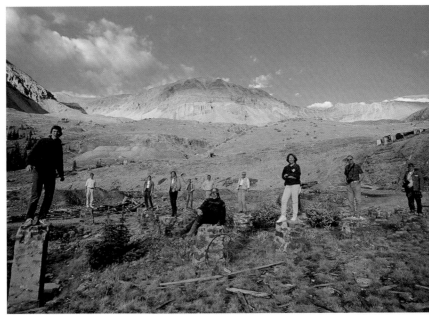

Robert Caputo

Make use of the environment. Instead of having everybody clump together for a group shot, look around. In this image, the foundations of an old house made perfect platforms, and spreading the group out enabled the image to include a lot of the environment.

You will probably be using a wide-angle lens, so be careful of distortion—you don't want the people at the edge of the frame to look like images in a funhouse mirror. Check your depth of field to make sure that everyone is in sharp focus. And beware of blinking—with an SLR camera you won't be able to see the actual moment, so make several frames to be sure you get one where no one has his eyes closed. Engage the group while you shoot—tell jokes if you want people to smile. And don't only shoot when everybody is in position. Make some images as they are on their way and after they have broken up. These are sometimes the best.

The other sort of group portraits are more imaginative, like the informal portraits with a twist that we discussed in Portraits. In these, you want to make a picture that not only shows all of the people, but also says something about

who they are. You want to choose a location, an angle, and a composition that make an image both of and about them. Depending on what sort of group it is and how game they are, you may want to do something off-beat.

Let's say you are shooting a swim team. You could have them all gather on the bleachers and do a straightforward portrait. Or you could do something different, maybe stand on the diving board and have all the swimmers in the water beneath you. Or get in the water and have them all diving into the pool toward you. Or take them out into a desert and shoot them wandering around looking lost.

Use your imagination. Find a way to relate the group to an environment that expresses something about what kind of group they are. Do it literally, humorously, dramatically, or by complete contrast. Get ideas from them.

And, again, look at work of this kind in magazines, books, and music CD covers. Don't be afraid to try things, no matter how outlandish they may first seem. Some of the best photographs of this sort are the ones that are really unusual.

Tip

Be careful if you are using a wide-angle lens to photograph a group. The people at the edges may get distorted.

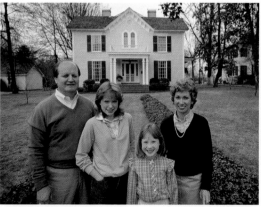
Bruce Dale

Even, diffused light and great depth of field allowed the photographer to get this pleasing image of a family and their house. Notice how he has posed the girl so that we can see the path leading up to the house.

OUR FAMILY MEMBERS are the people we photograph most frequently. We record the momentous occasions and the occasional moments. Albums full of baby pictures, first steps, Little League games, Halloweens, Thanksgivings, and weddings mark our passage through time. These photographs are our memories made real and are probably the most important pictures we will ever make or have. You should apply thought and technique just as rigorously, if not more so, to photographing your family as you do to any photo assignment.

There is no better group on which to practice photography. No others will be so trusting or willing to indulge your ever present camera, your fumbling around with lights, and your mistakes. When you are photographing strangers, you either get the picture or you don't. There is no going back to a fleeting moment. With your family, you can work on getting a similar moment again, and again, and again.

Practice all the techniques of composition and lighting we have discussed in this book. Working with your family will help you overcome the shyness we all feel when making pictures of strangers and enable you to get intimately familiar with your equipment and master the techniques for your other work.

Think hard about the people around you—what the basic aspects of their personalities are and how you can make photographs that reveal

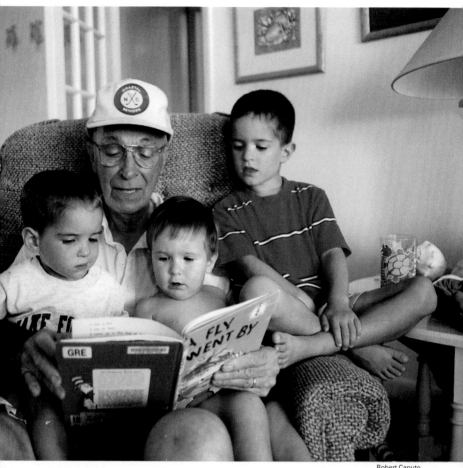

Robert Caputo

these. Make formal, informal, environmental, and group portraits—and ones with a twist. Make photo essays about your family and images of them in motion—frozen, blurred, and panned. Be sure to shoot a lot of film. You'll never have better subjects.

Always have your camera easily accessible when you are home, and carry it along on trips, whether to the grocery store or to Yellowstone. You should get to the point where you feel naked without it.

Approach photographing your family just as seriously as you would a client. For this image, I waited for the kids to get absorbed in the story Grandpa was reading, and used a diffused fill flash to add to the window light.

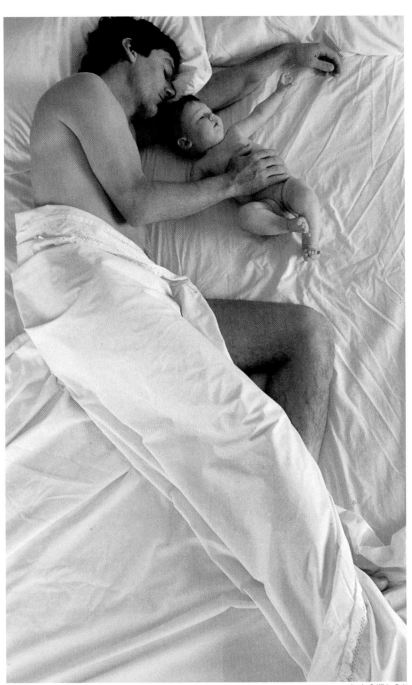

Annie Griffiths Belt

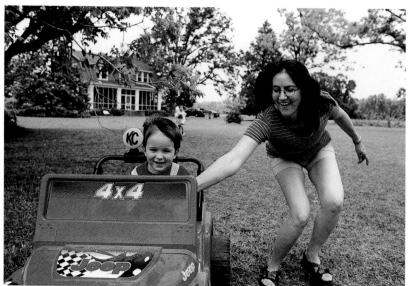

Robert Caputo

Parents

If you want to make images of your Dad, think about who he is. What does he do? What is he passionate about? What are the things he treasures? Make a formal portrait of him, trying to capture the person you know. Make an environmental portrait of him at work or in his den. Does he love to play golf? Go out on the course with him—making images as he swings his club is a great way to practice motion shots. Make a photo essay about his daily routine. Remember that you are after images of his personality, not just what he looks like. Make pictures both you and he will be proud of.

Do the same with your Mom. Then make images of the two of them together. Look for moments that express their relationship with each other. Don't just go for the clichés, like Dad giving Mom flowers on their anniversary. Find those little moments that happen every day around the house.

Whether shooting intimate or playful moments, always have your camera—and your eye—ready. With sleeping subjects (left) you can use a slow shutter speed to take advantage of the soft natural light. To capture the joy of a fleeting moment (above), you'll need a fast one.

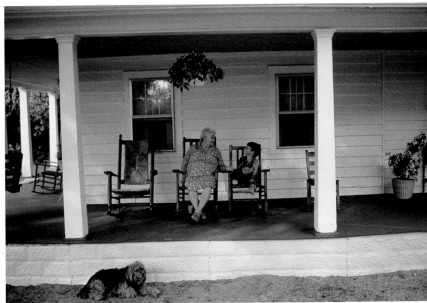

David Alan Harvey

Look for the wide shots, too. By including a lot of the porch, and the resting dog, the photographer gives us an evocative image of a visit to Grandma's house. A tighter shot would not have conveyed the same atmosphere.

Grandparents

When you visit the grandparents, make portraits and candids of all sorts. Think about who they are, where they live, and what that says about them. Perhaps Grandpa has a medal he was awarded during World War II, an old car he has lovingly tended, or just a hat he always wears. Perhaps Grandma has a painting of her mother she cherishes, or a typewriter she wrote her first story on. Look for things to incorporate into images that will tell a bit of the stories of their lives.

There are many special relationships here—between the two grandparents, between them and their daughter, their son-in-law, and of course their grandchildren. All will provide you with rich subject matter.

If you are with the grandparents for Thanksgiving or some other holiday, make a photo essay about it. Cover everything: the arrival of

far-flung relatives, cooking in the kitchen, the spread on the table, the tearful farewells. This is an opportunity to practice almost every technique we've talked about— candids, portraits, motion, lighting. When you get home, edit the essay and make copies for all the relatives.

Children

From the day they're born, we photograph practically everything that happens in our children's lives. Nowhere else is having your camera nearby and ready as important as in getting pictures of the kids—they do something impossibly cute, and then it's gone.

Have your camera close at hand and keep a fairly fast film (ISO 400) in it if you don't want to take the time to mount an electronic flash and wait for it to charge. If you use a flash, bounce it off the ceiling or wall or use a diffusion head to avoid red-eye and harsh shadows. Outdoors, try to use a fast shutter speed like 1/250 of a second if the kids are running around, and use a zoom lens so you can compose quickly.

Get involved with the children. Play ball, tell a story, participate in whatever they are doing. Ask

Tip

If kids want to look through the camera, let them. They will be more relaxed and cooperative. Just watch out for dirty fingers on the lens.

Children often want to run at you when you crouch down to make pictures of them, so be ready. Both of these images work, and I was able to get the one at right only because I followed focus on the boy as he ran toward me.

Robert Caputo (both)

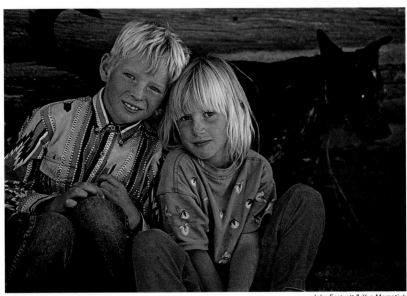

John Eastcott & Yva Momatiuk

It is important that children feel comfortable when you are photographing them. Get down to their level and joke around with them so you are less intimidating. Also pay attention to your background. In this image, the photographer decided to include the dog, too.

your son or daughter to show you a favorite toy. If they want to look through the viewfinder, let them. Kids have fairly short attention spans; they will soon forget about you and your camera and get back to what they were doing. And get down to their level. Photographs of children are usually more effective if you're not looking down on them but see the world from their perspective. Crouch, kneel, or lie down so you can see the expressions on their faces.

Look for the moment that expresses the feeling of the activity. If your kid is on a roller coaster, it's the mixture of fear and joy as it begins to plummet. If she's scored a goal, it is both the moment of the kick and the leap of celebration. If he's just finished building a tree house, it's the pride. Whatever it is, think about the activity and how best to portray it.

When you photograph a birthday party, be sure to get those moments we all want to see— blowing out the candles, opening the gifts,

smashing the piñata, pinning the tail on the donkey. You want to be able to see the candle flames, so use a shutter speed of 1/30 of a second or slower, depending on film speed. Use one of the motion techniques if they are playing tag. Make wide shots so you will see all the guests, and tight ones of the celebrant. Also look for other moments—the finger in the cake, the spilled juice.

At school plays, band concerts, graduations, and other events, don't be shy about getting the photograph you want. If you are seated far from the stage, get up and go to the front when you want to shoot. Kneel in the aisle to avoid blocking other peoples' views, make your frames, then return to your seat. Few people will object. If the event is indoors or at night, be mindful of the sort of light you are dealing with. And get back stage so you can get shots of the actors putting on their makeup and costumes.

In all of these events, you want images not only of your child but also some that express the feeling of the event. So as well as getting the moment when your child receives his diploma, get the moment his class expresses its elation.

When you are shooting a wedding, approach it as a photo essay—make a list of all the aspects you want to cover. Don't just start with the arrival of the bride, though. Go to the bachelor party. Visit the bride as she is getting her hair done and getting dressed. If you can, scout the location of the wedding beforehand so you know what sort of light and different environments you will have to deal with, and find out if there are restrictions on the use of electronic flash. Don't limit yourself to your shooting list. Keep an eye out for the serendipitous moments, the candids of the couple and the guests that tell the story of *this* wedding.

Tip

Anticipate kids' behavior. If they are playing tag, set up near the base, compose your image, and wait for them to come running in.

The Human Figure

Since cavemen first took charcoal to wall, painters, sculptors, and photographers have been fascinated by the human figure, and some have spent their entire lives trying to capture the nuances of its shapes and lines.

In portraiture we're interested in the personality of our subject, trying to represent on film a quality about a human being beyond the physical. Photographs of the human form are just the opposite—they are all about the physical manifestation of what the human animal is, of the body it inhabits. These photographs are studies in beauty and/or form. Some are idealized visions of the human body, a concept that, as any study of art history will show you, changes with the times.

Before you begin to make photographs of the human form, think about what it is that attracts you to it. Is it a silhouette, arms raised and feet spread, against a glorious sunrise, as if embracing a new day? Is it a head and torso, wet and glistening, rising from a dark sea? Is it a nude form, vulnerable soft curves of flesh, contrasted against the rigidity and agelessness of boulders? Is it the classic, abstracted S-curve of a hip?

> **Tip**
>
> To avoid being too anatomical when photographing the human form, try using soft focus or a little blur.

Careful timing and metering allowed the photographer to capture this swimmer at the right moment, when he was not obscured by foam. In-camera meters would tend to overexpose dark water, so remember to compensate.

Michael Nichols, National Geographic Photographer

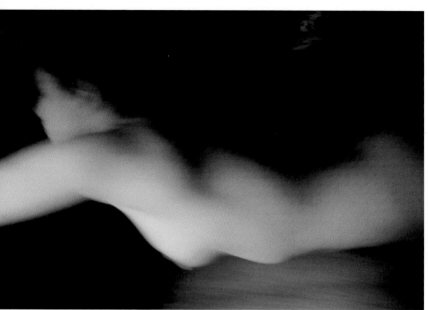

Bill Curtsinger

Whatever it is that attracts you, think of what it is you are trying to say with your images, then figure out the lighting and setting that will best help you achieve it. The silhouette of a human form against a gigantic clock says one thing, against a waterfall something else. A nude photographed in the studio is quite different from one photographed in a garden. As with all other photographs, images of the human form should be both *of* and *about* it. Your photograph should be not just a picture of a body, but one that says something about the body. Try not to be too literal or anatomical; photographs that hint or suggest are almost always more interesting and evocative.

Look at work done by painters, sculptors, and photographers in books, museums, and art galleries. Think about how they have treated their subject. What feeling do you get from their work? How did they achieve it?

A slow shutter speed created a slight blur in this beautiful image of a woman underwater, which evokes thoughts of mermaids. Think about what you want to say about the human form, and choose techniques that will enable you to say it.

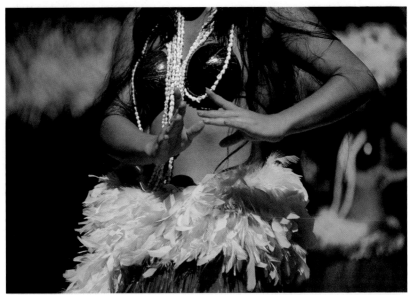

Jodi Cobb, National Geographic Photographer

Hands and Other Details

The hands of a farmer, a pianist, a baker. The feet of a ballet dancer, a long distance runner, a place kicker. The belly of a pregnant woman, the bicep of a weight lifter. Hair caressing a pillow, fingers clutched in prayer, a peering eye. The details of the human body make great photographic subjects, either as expressions of ideas or emotions, as graphic shots, or as a way to say something about an individual. Whenever you are photographing someone, try to think of details of their body or dress that would get your message across in an indirect way.

Are there particular parts of their body or items of what they wear that are important to what they do for a living or a hobby? Does some part of them really stand out? Can you find a way to abstract what you want to say about the person by using one of these elements?

For example, let's say you have three siblings.

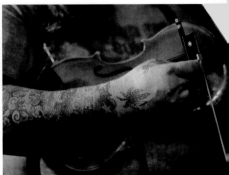

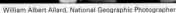

William Albert Allard, National Geographic Photographer

Bruce Dale

Three images of very different kinds of hands evoke three very different sorts of thoughts and emotions. When shooting details such as hands, think about who they belong to, what that person is about, and how much of the rest of the person you want to include or exclude.

One is a lawyer and very particular about appearance. One is a farmer who works in the fields, inevitably getting dirty. The third has a passion for tennis. If you make a portrait of the three of them together, their faces will tell much of the story. But also look at their shoes. Have them sit on the front porch and rest their feet on the railing. An image of the three pairs of shoes—highly polished and fashionable wingtips, dirty work boots, tennis shoes—will say much the same thing in a different and imaginative way.

The point is to use your eyes and your imagination, whether you want to use detail and abstraction to say something about an individual or about the beauty of the human body. If you are making photographs of details of the human body, you will be working intimately with people and will have to direct them, tell them where to pose, and how.

Think hard before the shoot so you know what to do when you get there.

Always look for details that convey something about your subject, as in this case

where a boot, spur, and pant cuff evoke the feeling of a cowboy on the plains.

LYNN JOHNSON
Honoring People's Stories

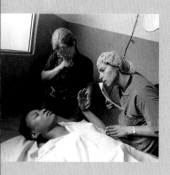

LYNN JOHNSON WAS a shy girl who spent a lot of high school poring over books in the library. One day, she happened upon a book of photographs by Dorothea Lange and other documentary photographers who had worked for the Farm Security Administration. It changed her life.

"I immediately fell in love with the power of those pictures," Johnson recalls. "In my short and rather sheltered life, I had never seen migrant workers or sharecroppers, and certainly had not experienced loss or pain like that, but I could feel it in those photographs. I had an emotional reaction to them I'd never felt. It made me want to pick up a camera."

She began by making photographs for her high school yearbook, an experience that allowed her to discover her innate talent and something more:

"When you're shy, a camera becomes an entry into life," she says. "It was a kind of shield I could hide my shyness behind, and it allowed me to become an active observer rather than a passive one."

Since then, this shy girl has climbed the radio antenna atop Chicago's John Hancock Tower,

Lynn Johnson (left) has made a career of getting close to people and allowing them to communicate their own stories through her powerful photographs.

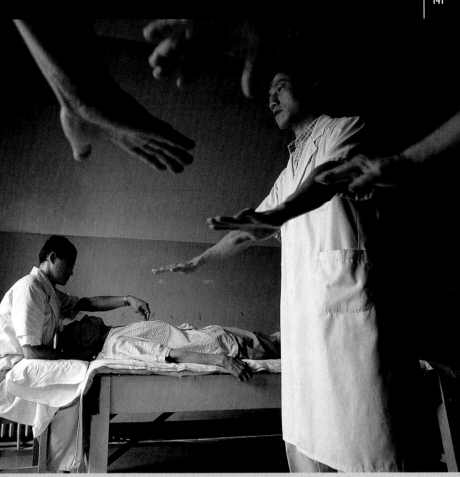

At a hospital in China, patients who suffer from diabetes practice exercises and meditation to lower their dependence on insulin. By crouching down and shooting from a low angle, Johnson captured this dramatic image of hands reaching toward the patient lying on the table.

clambered around scaffoldings with steel workers, and lived among fishermen on Long Island and guerrillas in Vietnam. She has done in-depth portraits of celebrities including Stevie Wonder, Michael Douglas, Mr. Rogers, and the entire U.S. Supreme Court. But Lynn Johnson's passion remains—just as it was kindled that day in her high school library— documenting the lives of regular people.

Her gripping photo essays of a family struggling with AIDS, of children coping with the brain death of their mother, and many others are honest and sensitive glimpses into the lives of ordinary people dealing with extraordinary

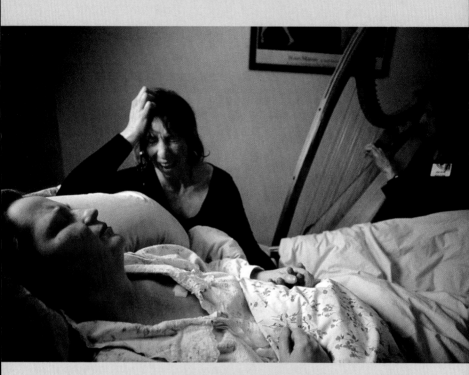

For a story on pain, Johnson visited this patient in her home a half-dozen times, and her intimacy with her subjects is evident in this heart-wrenching image. The harp is a prescription-ordered sedative that helps both the patient and her loved ones cope with the pain and stress.

circumstances, and are classics of the genre.

Telling those stories, and getting them in print, has not been easy. After graduating from the Rochester Institute of Technology, Johnson was hired as the first woman staff photographer at the *Pittsburgh Press:*

"Oh good," one of the older photographers at the paper told her when she arrived. "Now we have someone who can cover tea parties."

"Those guys were great, and great teachers, but they were also rather stuck in their time. Because I'm a woman, and because I'm small (she's 5' 1"), it never occurred to them that I could do more than cover social events. I needed to prove it to them. When photo assignments would come in, I didn't wait for one to be handed to me. I'd just grab the one I wanted— without telling anyone—and go off and do it."

She stayed at the newspaper for seven years, and during that time she convinced the editors of the Sunday magazine to let her do photo essays.

"I was getting frustrated with the quick in and out of spot news," Johnson says. "I felt that a lot of the stories needed more space, just out of a sense of fairness to the subjects."

When she left the *Pittsburgh Press*, she was invited to participate in a project to document fishermen on Long Island called "Men's Lives."

"It was a true documentary project. Adelaide DeMeril, the woman who supported it, said, 'Go take pictures, go honor these people's lives.' The other photographers and I never had to justify a single frame or a single dime. I worked on the project off and on for a year, and it really prepared me for the kind of work I've been doing ever since.

"The emphasis in doing any in-depth photography is on building relationships, quality relationships. It's what I call thirty-cups-of-coffee-a-frame photography. You need to enter into the community—not just photographically, but intellectually and emotionally. And I began to understand the idea of education through photography and the importance of photographs over time.

"Photographs help people look at things they may not be able or may not want to look at," says Johnson. "Until you can look at something, you can't change it. First you have to look at it, then you have a chance to understand it and can change it.

"For me, photography has been a mission. I don't mean a mission on the grand scale, but in the sense of the daily awareness that each one of us is responsible for the wider community, that your sense of self and sense of responsibility

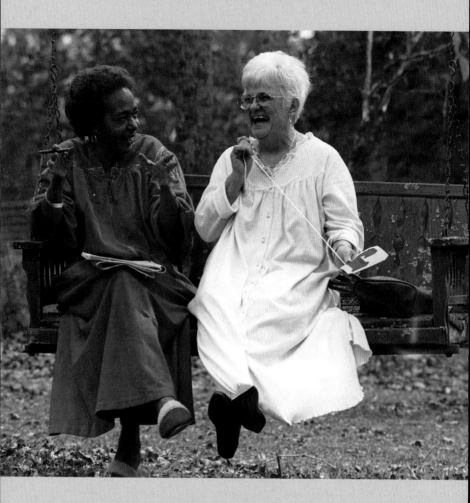

outside yourself is as wide as you can embrace. It's a commitment to try to fulfill that responsibility by doing work about things that matter."

Johnson's commitment and her sensitivity are evident in her photographs. Few other people are able to enter into the lives of others with such emotional and photographic intimacy, and Johnson attributes her ability to do so to a simple priority.

"The people—the relationships and the experiences—are more important than the photo-

Covering the trial of a hate crime in Jasper, Texas, for *Life* magazine, Johnson wanted to get beyond the obvious. She spent a lot of time roaming around the community to try to understand the people's feelings about race. When she

graphs," she says. "As journalists, our responsibility is not to manipulate people, but to honor them and their stories," she says.

"The only time I literally shake with fear," she says, "is not when the situation is physically dangerous, but when it is emotionally charged. I try to be careful not to impact the emotional terrain, to be aware of and sensitive to how much pain someone is in, and always aware how much of a gift being in their presence is."

She prepares for her assignments by reading a lot and listening to people talk about the subject. "I like hearing people's voices," she says. "Research is an internal process of becoming aware of and comfortable with the material, an incremental education that fills you with the subject."

Lynn Johnson is currently working on long-term projects about hate crimes and women's health care.

met these two women and discovered that they are best friends who spend every morning together, she knew that she had something that would add a welcome and different dimension to her story.

Johnson's Photo Tips

- Travel light. Never carry more than you can run with.

- Know your gear so well that it becomes a part of you, so that you can reach for it without looking.

- Pick a community, big or small, and get involved. Not just photographically, but with your mind and heart.

- Don't live in a bub- ble. You can't communicate about other people if you are not exposed to them.

- Choose the kind of photography that will get you involved with the kind of people you want to be with, not the other way around.

- Don't wait for the phone to ring. Give yourself an assignment, get involved, and go do it.

THE WAY TO APPROACH A PHOTOGRAPHIC ESSAY is the same way you would approach a written one. First you would think about who your subject is: what she looks like, where she lives, where she works, the kind of work she does, the kind of personality she has. A written essay strives to communicate a physical description of a person, a factual account of the setting he is in and what he does, and an emotional and intellectual glimpse of his life. Photographic essays should do the same.

When you are making a photographic essay, think about the techniques of composition we discussed earlier. Use them or break them as the situation warrants. And practice, practice, practice. You want to be so familiar with your tools and how they work that you don't have to think about them. You want to have trained your eye so that the play of light and the composition become almost automatic, so that you can easily sense what feels right when you look through the viewfinder.

Modern cameras can make perfectly exposed and focused pictures all by themselves. But cameras cannot compose photographs. They cannot make choices about what to include or exclude from the frame, and they certainly cannot distill information or feelings into visual representations. Only people can communicate ideas and emotions.

Annie Griffiths Belt

In Several Pictures

Most photo essays are a group of pictures that tell a story about someone over a period of time—it can be five minutes or several years, depending on the story you wish to communicate. The first and most important step is to determine what the story is and figure out the kinds of images you will need to convey it.

For example, let's say you've chosen a high school teacher as your subject. Talk to her, explain what you want to do and why, and get

For a photo essay on a typical American woman, photographer Annie Griffiths Belt took this image of Pattie Skeen and her daughter, Julie. Notice how the frame is devoid of any background details that would detract from the impact of the portrait.

her permission. You'll be spending a lot of time with her, so be sure she understands what the project will involve and is willing to cooperate.

Spend a few days with her without making photographs. This gives the subject, her family, and her students time to get used to your presence and allows you to establish some rapport with the teacher and the people around her. It also helps you figure out what to shoot.

Next, make a shooting list of images you would like to get. It might include the following:

1. Breakfast with the family.
2. The commute to school.
3. The teachers' lounge.
4. In the classroom.
5. Lunch in the cafeteria.
6. Meetings with students or parents.
7. Coaching the swimming team.
8. Dinner with the family.
9. Helping her own kids with homework.
10. Grading papers late at night.

It's not enough to just get pictures of each one of these situations. Within each one, think about and look for the decisive moment that captures the look and feeling, the essence, of that particular part of her life.

At breakfast it might be when she pours juice, but it might also be a few minutes later when she helps her child put on his backpack. In the classroom it might be when she bends over a student at a desk to help with a problem or when she reads a scene from a Shakespeare play to her class. At night it might be as she rests her weary head on her hand as she grades her students' papers. It is up to you to find the moment in each situation that best tells the story. Each of the pictures should be able to stand alone as a good photograph.

Because the photographer spent time with her subjects, she could put them at ease and capture moments at home (opposite) and at church (below), where Pattie hosted a sleep-over. Pattie was shy when alone with the photographer, but quickly overcame her self-consciousness when with a group.

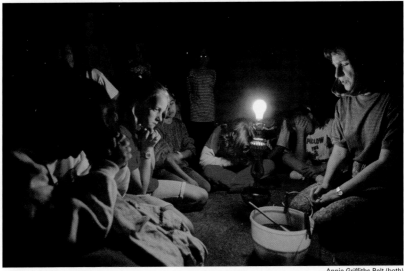

Annie Griffiths Belt (both)

Also think about "push" and "pull" in a photographic essay. You want to include intimate portraits, medium shots, and wide ones that really show the environment.

When you get the film back, edit it carefully. Choose only the best images from each situation, remembering to include both tight and wide shots. If there is a situation you didn't get, think about why. What should you do to make it better?

Then go back and do it again. There's nothing wrong with going back. Your subject will usually be quite willing if you explain why you need to. Both of you want the photo essay to be the best it can be.

The best way to learn about photo essays is to study the work other photographers have done in this genre. Go to a library or bookstore and look at a number of different books of photographic essays. Also try to find copies of old *Life* and *Look* magazines. They contain some of the best photo essays ever done.

Choose someone you know—a member of your family, a neighbor, a roommate if you are in college—and make a photographic essay about him or her. Keep at it until you are both happy with the results.

In One Picture

The Chinese proverb says "One picture is worth ten thousand words."

Sometimes a photographic essay can be boiled down to a single image—that one shot that somehow captures the physical attributes, environment, emotion, and the idea. Spend time with your subject, and think about the singular life of that individual. Determine the setting, time of day, activity, and lighting that would best

Tip

When you are in people's homes or workplaces, carry as little gear as possible. You want to minimize the disturbance your presence causes.

Waiting in their minivan, Pattie helps son Michael with his homework (above) while Julie has a piano lesson. Later that evening, Pattie comforts Julie (below), who was not feeling well. In all these images, the subjects seem perfectly comfortable and at ease, and we are privileged to get a real glimpse of their lives.

Annie Griffiths Belt (both)

This single image tells a whole story about a nun at the Ephrata Cloisters in Pennsylvania. We get a sense of her environment and, because she is engrossed in her work and we can see the results of it, the image is a revealing glimpse into how she spends her days. Always remember that good photographs of people are both *of* them and *about* them.

sum up who you interpret that person to be. Think of the one-image photo essay as a haiku rather than a narrative poem.

When you have made your photo essay about the teacher, family member, or roommate, look for one image that could stand alone and summarize all of it. If you don't have one, what image would do it?

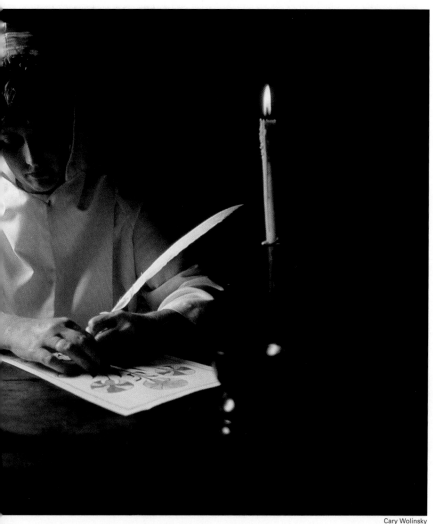

Cary Wolinsky

What is the essence of the person's life or the event you are covering? Where do you find the most passion? Figure out a way to capture it, and go back and do it.

Look at the work of other photographers. Think hard about how they achieved their results, and use that knowledge to improve your own images.

CHECKLIST

Camera Bag Essentials

camera bag lined with foam rubber
 compartments
camera body with body cap and
 neck strap
favorite lenses with lens caps
lens hoods
film of various ISO ratings or disk
 cards for digital cameras
air blower brush
lens cleaner solution and lens
 tissue wipes
electronic flash
exposure meter and
 flash batteries
remote release

Options

filters such as UV haze, skylight 1A,
 polarizing, neutral density, graded neutral
 density, light amber, light blue
plastic bag or sheet to protect equipment
 in wet weather
equipment manuals
soft absorbent towel or chamois
silica gel for wet weather
tripod, monopod, and/or bean bags
large umbrella
cooler for hot weather
extra camera body
extra electronic flash
extra handheld exposure meter
selenium cell exposure meter that operates
 in cold weather
gaffer's tape
notebook and permanent marker
self-stick labels to identify film
sunglasses
head and wrist sweat bands
18% gray card
re-sealable plastic bags for storing film
customized diopter to match your
 eyeglass prescription
reflectors
slave units and radio transmitter for
 electronic flash

Tool Kit

film changing bag
film leader retriever
Swiss army knife
filter wrench
small socket wrenches
jeweler's screwdrivers
tweezers
needle-nosed pliers to loosen jammed
 tripod joints

Safety

flashlight
compass
whistle
water
snacks
medical first aid kit
reflective tape for clothing during
 nighttime shooting

WEB SITES

The Web is an invaluable resource for all
sorts of photography. Most photographic
magazines have Web sites, as do photo-
graphic agencies and individual photogra-
phers. You can join discussion groups, read
articles by and about photographers, and
look at a wealth of images. If you are travel-
ing, you can check the weather and get tips
on where to go and what to see. Use a
search engine to find sites by photogra-
pher's name or by key word.

 The following is a partial list of Web sites
to get you started. Remember that sites can
change or even disappear. There is no sub-
stitute for surfing.

AOL Photography Forums
 on AOL only; keyword: Photography
American Society of Media Photographers
 http://www.asmp.org
Apogee On-Line Photo magazine
 http://www.apogeephoto.com
Beststuff.com
 http://www.beststuff.com
Camera Arts magazine
 http://www.cameraarts.com

Camera & Darkroom News
http://www.camera-darkroom.com

Camera Shows/Photorama
http://www.photorama.com

Cary Wolinsky
http://www.carywolinsky.com

CompuServe Photography Forums
(on Compuserve: "go photoforum")

E-Digital Photo magazine
http://www.edigitalphoto.com

Image Soup Magazine
http://www.netcontrol.net

Lynn Johnson
http://www.auroraphotos.com

National Geographic Society
http://www.nationalgeographic.com

Outdoor Photographer magazine
http://www.outdoorphotographer.com

PC Photo magazine
http://www.pcphotomag.com

PhotoSecret's Links to Photo and
Travel Sites (also called Travel Guides
for Travel Photography)
http://www.photosecrets.com

Photo Books
http://www.amazon.com
http://www.barnesandnoble.com
http://www.buybooks.com

Photo District News magazine
http://www.pdn-pix.com

Photo Electronic Imaging magazine
http://www.peimag.com

Photo Travel Guides Online
http://phototravel.com/guides.htm

Photograph America newsletter
http://www.photographamerica.com

PHOTO LIFE magazine (Canada)
http://www.photolife.com

PhotoPoint magazine
http://www.photopoint.com/phototalk/
magazine

Popular Photography magazine
On AOL only;
keyword: POP PHOTO

Professional Photographers of America
(PPA) http://www.ppa-world.org

Robert Caputo
http://www.robertcaputo.com

Shaw Guides to Photo Tours and Workshops http://www.shawguides.com

Shutterbug magazine
http://www.shutterbug.net

Weather Channel http://www.weather.com

PHOTOGRAPHY MAGAZINES AND BOOKS

Magazines

The photography magazines listed here have to do largely with technique. But of course pictures of people appear in just about every magazine published, so look closely at others to see how photographers have treated their subjects. I strongly recommend going to a library and looking at old issues of *Life* and *Look*.

American Photo. Bimonthly publication with features on professional photographers, photography innovations, and equipment reviews.

Camera Arts. Bimonthly magazine including portfolios, interviews, and equipment reviews.

Digital Camera. Bimonthly publication emphasizing digital cameras, imaging software, and accessories.

Digital Photographer. Quarterly publication emphasizing digital cameras, accessories, and technique.

PC Photo. Bimonthly publication covering all facets of computers and photography.

Petersen's PHOTOgraphic. Monthly publication covering all facets of photography.

Photo District News. Monthly business magazine for professional photographers.

Photo Life. Bimonthly publication with limited availability in the U.S. Covers all facets of photography.

Popular Photography. Monthly publication covering all facets of imaging from conventional photography to digital. Heavily equipment oriented, with comprehensive test reports.

Practical Photography. Monthly. Technique, equipment, and general interest for amateur photographers.

Shutterbug. Monthly publication covering all facets of photography from conventional to digital. Also includes numerous ads for used and collectible photo equipment.

View Camera. Bimonthly magazine covering all aspects of large-format photography.

Books

The following is a partial list of books about photographic techniques, composition, and the like. Books *of* photographs are far too numerous to list here. Go to book stores and libraries and study the work of photographers who make the sort of images you are interested in.

General Photography Books

Jenni Bidner, *Great Photos with the Advanced Photo System*, Kodak Books, Sterling.

Hubert Birnbaum et al., *Advanced Black-and-White Photography*, Kodak Workshop Series, Silver Pixel Press.

Hubert Birnbaum, *Black-&-White Darkroom Techniques*, Kodak Workshop Series, Kodak Books, Sterling.

Peter K. Burian and Robert Caputo, *National Geographic Photography Field Guide*, National Geographic Society.

Derek Doeffinger, *The Art of Seeing*, Tiffen Company.

Eastman Kodak Company Staff, *Basic Developing and Printing in Black and White*, Tiffen Company.

Eastman Kodak Company Staff, *Kodak Guide to 35mm Photography*, Tiffen Company.

Eastman Kodak Company Staff, *How To Take Good Pictures*, Ballantine Publishing Group.

Eastman Kodak Company Staff, *Kodak Pocket Photoguide*, Tiffen Company.

Eastman Kodak Company Staff, *Kodak Professional Photoguide*, Tiffen Company.

Lee Frost, *The Question-and-Answer Guide to Photo Techniques*, David & Charles.

Tom and Michele Grimm, *The Basic Book of Photography, 4th ed.*, Dutton Plume.

John Hedgecoe, *The Art of Colour Photography*, Focal Press.

John Hedgecoe, *The Photographer's Handbook*, Alfred A. Knopf.

John Hedgecoe, *John Hedgecoe's Complete Guide to Photography*, Sterling.

John Hedgecoe, *John Hedgecoe's Photography Basics*, Sterling.

Roger Hicks and Frances Schultz, *The Black & White Handbook*, David & Charles.

Bob Krist, *Secrets of Lighting on Location: A Photographer's Guide to Professional Lighting Techniques*, Watson-Guptill.

Barbara London (Editor), and John Upton (Contributor), *Photography*, Addison-Wesley.

Joseph Meehan, *The Art of Close-up Photography*, Fountain Press.

Bryan Peterson, *Learning to See Creatively*, Watson-Guptill.

Bryan Peterson, *Understanding Exposure*, Watson-Guptill.

Bernhard J. Suess, *Creative Black & White Photography*, Allworth Press.

Martin Taylor, *Advanced Black-&-White Photography*, Tiffen Company.

William White, Jr., *Close-Up Photography*, Kodak Workshop Series, Tiffen Company.

Equipment-Oriented Books

Peter K. Burian, Editor, *Camera Basics*, Eastman Kodak, Silver Pixel Press.

Eastman Kodak Company Staff, *Kodak Camera Basics*, Tiffen Company.

Eastman Kodak Company Staff, *Using Filters*, Tiffen Company.

Joseph Meehan, *Panoramic Photography, Revised Edition*, Amphoto.

Joseph Meehan, *The Complete Book of Photographic Lenses*, Amphoto.

Joseph Meehan, *The Photographer's Guide to Using Filters*, Amphoto.

Jack Neubart, *Electronic Flash*, Tiffen Company.

Steve Simmons, *Using the View Camera*, Watson-Guptill.

Computer and Photography Books

Jenni Bidner, *Digital Photography*, Kodak Workshop Series, Silver Pixel Press.

Joe Farace, *Digital Imaging: Tips, Tools and Techniques for Photographers*, Focal Press.

Tim Fitzharris, *Virtual Wilderness: The Nature Photographer's Guide*, Watson-Guptill.

Kodak Workshop Series, *Digital Photography*, Eastman Kodak, Silver Pixel Press.

John J. Larish, *Fun With Digital Photography*, Kodak Books, Tiffen Company.

Rob Sheppard, *Computer Photography Handbook*, Amherst Media.

People Photography Books

Roger Berg, *Profitable Portrait Photography*, Amherst Media.

Helen T. Boursier, *Black and White Portrait Photography*, Amherst Media.

Helen T. Boursier, *Family Portrait Photography*, Amherst Media.

Eastman Kodak Company Staff, *The Joy of Photographing People*, Addish Wesley Longman.

Eastman Kodak Co., *The Portrait*, Kodak Books, Silver Pixel Press.

John Hedgecoe, *Photographing People*, Watson-Guptill.

Miscellaneous Books

Leah Bendavid-Val and Barbara Brownell, Editors, *National Geographic Photographs Then and Now*, National Geographic Society.

Leah Bendavid-Val, *National Geographic: The Photographs*, National Geographic Society.

Jodi Cobb, *Geisha: The Life, the Voices, the Art*, Alfred A. Knopf.

James L.Stanfield, *Eye of the Beholder*, National Geographic Society.

Priit Vesilind, *National Geographic On Assignment USA*, National Geographic Society.

Cathy Newman, *Women Photographers at National Geographic*, National Geographic Society.

Robert Caputo, coauthor of the *National Geographic Photography Field Guide*, has been photographing and writing stories for the National Geographic Society since 1980. His award-winning work has also appeared in numerous other magazines and has been displayed in international exhibitions. Publisher of two children's wildlife books and two photo essay books, *Journey up the Nile* and *Kenya Journey*, Caputo appeared in and wrote the narration for the National Geographic Explorer film *Zaire River Journey* and wrote the story for and was associate producer of *Glory & Honor*, the TNT Original film about the discovery of the North Pole. He lives in Washington, D.C.

National Geographic
Photography Field Guide
People & Portraits

Robert Caputo

Published by the National Geographic Society

John M. Fahey, Jr., *President and*
Chief Executive Officer

Gilbert M. Grosvenor, *Chairman of the Board*

Nina D. Hoffman, *Executive Vice President*

Prepared by the Book Division

Kevin Mulroy, *Vice President and Editor-in-Chief*

Charles Kogod, *Illustrations Director*

Marianne R. Koszorus, *Design Director*

Staff for this Book

John G. Agnone, *Project Editor and*
Illustrations Editor

Rebecca Beall Barns, *Text Editor*

Joan Wolbier, *Designer*

Cinda Rose, *Art Director*

Charlotte Fullerton, *Researcher*

Bob Shell, *Technical Consultant*

R. Gary Colbert, *Production Director*

Lewis Bassford, *Production Project Manager*

Sharon K. Berry, *Illustrations Assistant*

Susan Nedrow, *Indexer*

Manufacturing and Quality Control

George V. White, *Director*

John Dunn, *Manager*

Phillip L. Schlosser, *Financial Analyst*

CIP data applied for

One of the world's largest nonprofit scientific and educational organizations, the National Geographic Society was founded in 1888 "for the increase and diffusion of geographic knowledge." Fulfilling this mission, the Society educates and inspires millions every day through its magazines, books, television programs, videos, maps and atlases, research grants, the National Geographic Bee, teacher workshops, and innovative classroom materials.

The Society is supported through membership dues, charitable gifts, and income from the sale of its educational products. This support is vital to National Geographic's mission to increase global understanding and promote conservation of our planet through exploration, research, and education.

For more information, please call 1-800-NGS LINE (647-5463) or write to the following address:

National Geographic Society
1145 17th Street N.W.
Washington, D.C. 20036-4688 U.S.A.

Visit the Society's Web site at
www.nationalgeographic.com.

FRONT COVER: Whether photographing family or strangers, always be on the lookout for the telling moment, as in this image of a young cowgirl's obvious pleasure.

Annie Griffiths Belt